"Kimberly Coffman is an expert in helping entrepreneurs, small business owners, and socially responsible companies hone their operational practices within a shifting global marketplace. Coffman's experience includes examples of challenges and successes across industries. *Supplier Diversity from the Inside Out* is a timely resource to reimagine supply chains that match a desired customer base.

This book is comprised of in-depth illustrations and theoretical models for working with diverse demographics. The discussion moves from contemporary limits to robust possibilities. Topics include key terms, recommendations for marketing, professional resources, and strategies for implementation. *Supplier Diversity from the Inside Out* is required reading for anyone committed to doing better business in a better world."

—Mark C. Hopson, Ph.D.
Professor and author of *Communicating Interculturally: Theories, Themes, and Practices for Societal Wellbeing*

"Kimberly Coffman has consistently championed supplier inclusion and the growth of diverse-owned firms for over two decades. Having benefited from her mentorship firsthand, I can attest to her prowess in fostering relationships and creating meaningful connections. Kimberly's dedication is evident not only through the countless intentional introductions she's facilitated for me

and other diverse-owned enterprises, but also through her impactful live presentations.

She's passionate about guiding diverse firms with best practices, ensuring optimal outcomes for all stakeholders involved. Kimberly's expertise is invaluable for diverse-owned entrepreneurs aiming to navigate the nuances of marketing to large buying organizations, supplier diversity professionals, and strategic sourcing managers. Simply put, if you're seeking insights from the industry's best, look no further than Kimberly."

—**Karen Scarpino,** Owner & CEO
Green Giftz | Promotion Impact

"I met Kimberly while attending a Women's Business Enterprise National Council (WBENC) conference. She was representing a major airline, and I had recently launched a business that included a new category of reusable bags to, among others, the hospitality industry.

By fate/chance, I sat next to her at a luncheon. When she heard what I did, her eyes lit up and she said, "I was just asked by one of my buyers to look for garment suppliers!"

From that meeting, Kimberly introduced me to her colleagues, I participated in several RFPs (requests for proposals), and I worked on a myriad of projects as a trusted vendor and a sustainability consultant. I was invited to her company's headquarters to meet their supply chain executives, and eventually participated in the company's eighteen-month Supplier Development Academy, an inclusive mentorship program created to help small diverse-owned businesses grow and scale.

Throughout my experience with Kimberly, not only was she gracious, but she was genuinely interested in my products and my mission to eradicate single-use dry cleaning plastic. I have Kimberly to thank for showing interest, offering mentorship, and sharing happiness for my company's successes."

—**Jennie Nigrosh,** CEO of The Green Garmento LLC, Climate Crusader, Solutions-Driven Strategist, Catalyst for Change

"I have had the privilege of witnessing firsthand Kimberly Coffman's unwavering commitment to supplier inclusion and the advancement of diverse-owned businesses. Kimberly's astuteness in this area is truly remarkable, as she consistently goes above and beyond to advocate for supplier inclusion and provide invaluable strategies and connections to propel the growth of the small and diverse-owned businesses she mentors.

Her dedication to coaching and advising small and diverse-owned businesses is evident through the tangible impact she has had on their success stories. Kimberly's expertise in supplier diversity, small business coaching, and advocacy is not only impressive but also genuinely transformative. I happily endorse Kimberly Coffman for her outstanding work in championing supplier diversity and nurturing the prosperity of diverse-owned businesses."

—**Dr. Felicia Phillips,** Founder & CEO
The One Million Dreams Foundation for Black Women & Girls Inc.

Sylvester,

SUPPLIER
DIVERSITY
FROM THE
INSIDE
OUT

Achieve all you
desire.

Kim R. Coffs

SUPPLIER DIVERSITY

FROM THE

INSIDE OUT

A Corporate Insider's Guide to
Making Diverse-Owned Businesses
Stand Out from the Crowd

KIMBERLY R. COFFMAN

publish
y*ur gift

SUPPLIER DIVERSITY FROM THE INSIDE OUT
Copyright © 2024 Kimberly R. Coffman
All rights reserved.

Published by Publish Your Gift®
An imprint of Purposely Created Publishing Group, LLC

DISCLAIMER
This book is intended for informational purposes only. Users of this guide are advised to do their own due diligence when it comes to making business decisions and all information, products, and services that have been provided should be independently verified by your own qualified professionals. By reading this guide, you agree that the author is not responsible for the success or failure of your business decisions relating to any information presented in this book.

ISBN: 978-1-64484-644-8 (print)
ISBN: 978-1-64484-644-5 (ebook)

Special discounts are available on bulk quantity purchases by book clubs, associations and special interest groups. For details email: sales@publishyourgift.com or call (888) 949-6228.

For information log on to www.PublishYourGift.com

I dedicate this book to you—
the small business owner, the minority, woman,
Veteran, LGBTQ+ and disability-owned entrepreneur.

You are the reason for supplier diversity. Our society and
healthy economy are the beneficiaries of your success.

You are the original risk-taker—pursuing your dream,
creating a business, employing talent, and serving
your customers.

Without you, society would continue to have a want,
a need, a desire. Thank you for dreaming up ideas,
creating solutions, and fulfilling our needs.

I appreciate and thank you!

TABLE OF CONTENTS

FOREWORD

As President and Chief Executive Officer of the Atlanta Business League, I understand supplier diversity from a one-of-a-kind perspective. Iconic educator Booker T. Washington formed the National Negro Business League in 1900 to advocate for Black businesses. Atlanta is the last thriving chapter of his organization and in 2023, we celebrated our official ninetieth anniversary.

I see diversity, equity, and inclusion both historically and from my thirty years of interacting with top-tier professionals who take it seriously. For that reason, I can say with authority that Kimberly Coffman has written a book that serves two purposes. It should be the roadmap for any corporation that wants to establish an effective, profitable, and diverse supply chain management program. It also offers tools and coaching advice to small and diverse-owned business entrepreneurs that will make their skills or services more attractive in the corporate supplier diversity landscape.

Kimberly has more than twenty years of experience in procurement purchasing and supplier diversity. She has worked in manufacturing, aviation, and the financial services industries. She understands supply chain diversity from multiple perspectives and has authored this book to explain why supplier diversity exists and how changing demographics in the United States are motivating more

companies to consider implementing diversity, equity, and inclusion (DEI) programs.

I first met Kimberly in 2014, after one of our organization's major supporters, Delta Air Lines, recruited her to work in its supplier diversity department. She immediately impressed me with her belief that she could make a positive difference for both her company and the small business owners who wanted to become its suppliers. She spent years accomplishing those goals at such a high level of efficiency that a different corporation recruited her to build its supplier diversity program.

Kimberly knows that supplier diversity programs only work when they are implemented properly and are more than simply words written in a document. This book shows the value of such programs to the companies that operate them and how entrepreneurs who follow her advice can create generational wealth, independence, and help others while having financial success for themselves.

Kimberly, I applaud your excellence. I applaud your tenacity. I applaud your commitment to making a difference in the supplier diversity arena. This book is simply a concrete example of your passion.

Congratulations, my friend. Continue doing the work.

Leona Barr-Davenport
President & CEO, Atlanta Business League

INTRODUCTION

For twenty years, I have been advocating for the inclusion of small and diverse-owned businesses into corporate supply chains. When I began this work, I literally learned how to be a supplier diversity professional from the ground up. I began my supplier diversity career with a bang, helping both small, diverse-owned firms and multi-billion-dollar corporations win projects and contracts.

During this time, I served on numerous boards and committees. I met and worked with supplier diversity experts from GM, Accenture, UPS, and many more. My peers and I shared and discussed best practices. We learned about each other's programs and what our respective companies procured. We became each other's extended team members and family in a small, tight-knit community.

We talked about the prospective suppliers we encountered and referred the best ones to each other. We did this because we understood that our role wasn't to compete with one other, but to collectively work to advance supplier diversity and build up this community at large.

Some of the prospective supplier experiences we discussed were success stories, while some of them were disappointments. Most prospects were simply amazing, with incredible elevator pitches and capability presentations, earning stellar reputations for making us feel comfortable and confident referring them to our

colleagues. While some others fell short in how they treated the supplier diversity engagement process and the very people trying to open the doors of opportunity to them. If you can believe it, some of these engagements with supplier diversity professionals, corporate buyers, and supply chain executives were disrespectful and rude.

These latter types of encounters can make our jobs very difficult to advocate for and promote supplier diversity and individual diverse-owned businesses because, whether fair or unfair, the poor behavior of one diverse supplier places a blanket of negativity across the rest.

What I learned from these experiences is that there is still a need to connect, coach, mentor, and advise some small and diverse-owned businesses to be more successful in how they market themselves and their companies to supplier diversity and purchasing decision-makers.

There's an opportunity to better train, develop, and equip them to engage and pursue con-tracts with large corporations and other institutional buying organizations in healthcare, academia, entertainment, government, and others. As I think about generational cycles, the insights, stories, and resources shared here hopefully will contribute to my legacy and my ability to inspire and help catapult emerging entrepreneurs on their pathway to success.

With my work and expertise within a large corporate supply chain organization, I don't always have the time nor the opportunity to fully coach and lend my insights to every small or diverse-owned business entrepreneur I encounter. This book is a way for me to formally do that and to speak to them directly.

HOW TO USE THIS BOOK

This book was meant to be a guide, a companion piece to the wealth of knowledge you've already gained from your educational, professional, business, and personal experiences.

When using this book, if you're a linear learner like me, I suggest you read it in chronological order. If you're more of a non-linear learner, if you have a specific goal in mind, are on deadline, or if there is a chapter that stoked your interest as you contemplated purchasing this book, then please start where your heart is moving you to begin.

1
DEFINING SUPPLIER DIVERSITY

What is supplier diversity?

Like you, the first time I heard the term "supplier diversity," I wasn't sure what the term meant. Sure, I had heard the term supplier and the term diversity used independently many times, but the coming together of these two words sounded special. It was a new and intriguing pairing.

Not only was the term supplier diversity unique, but I also later learned that it was an emerging concept and philosophy in the world of business that was about to transform my life and career and take me on a journey that I had not dreamt of nor imagined for myself. It was also a term that had already been transforming what's called "diverse-owned business enterprises," those owned by minorities and women since the civil rights era, which we'll define a little later on.

To this day, supplier diversity remains an unfamiliar term to most and an increasingly emerging concept both within and outside of the United States. So, just like my in-person and virtual training on this topic, it helps to begin this book by establishing a shared understanding of the term.

I've seen many definitions for supplier diversity over the years. However, the one I like to use defines supplier diversity as "a proactive business process that seeks to provide all suppliers with equal access to purchasing opportunities and promotes supplier participation that reflects the demographic make-up of the United States. Its goal is to support the diverse business community by fostering growth, economic development, and economic empowerment, and helps level the playing field for historically underutilized suppliers." I'm not sure to whom I attribute this definition, but I want to thank them for it. It's a good one.

What supplier diversity means is that large corporations and other purchasing entities have intentionally created a department, team, processes, and resources to actively research, identify, vet, and refer qualified small and diverse-owned businesses to their purchasing departments and internal teams. The goal is to include these types of businesses in their sourcing projects. This intentional act of supplier inclusion allows small and diverse-owned businesses the opportunity to compete for and possibly win the goods and services contracts of a company, as well as to take part in America's free enterprise system.

Some companies establish supplier diversity programs as a response to compliance requirements from the federal government or other customers, while others begin their supplier diversity operations on their own because it makes good business sense—it allows them access to a broader pool of prospective vendors, or to make their sourcing process more competitive which could return advantages to their company.

The spirit of supplier diversity is fundamental to free enterprise, allowing all citizens from all communities who have a business, experience, and the wherewithal to provide a good or a service to compete. It's about providing opportunities for historically underutilized businesses (HUBs)—owned by people who are racial or ethnic minorities, women, Veterans, service-disabled Veterans, people with disabilities, those who identify as LGBTQ+, and small businesses as defined by the U.S. Small Business Administration.

All entrepreneurs should have the opportunity to create a business, serve customers, hire, train, and develop employees who may, in turn, utilize the services of their customers and others while helping propel the US and global economies forward.

If only a portion of society is allowed the opportunity to become suppliers to large buying organizations, then there is an economic disadvantage, a rift that occurs. This imbalance could cause chaos, loss of jobs and wages, reductions in education, increases in crime, and other negative societal implications.

When the spirit of supplier diversity is in full force, everybody wins!

2

CORPORATE BUSINESS CASE AND VALUE PROPOSITION

With all the competition out there, do large corporations really do business with small and diverse-owned firms?

Government agencies, large corporations, and other buying institutions each have their own reason for implementing a supplier diversity program and doing business with small and diverse-owned firms. According to their corporate culture, business regulations or other compliance matters, the business case and value proposition for supplier diversity may be justified by several factors. The traditional business case and value proposition and the reason for most supplier diversity programs continue to evolve. Let's look at eight critical mainstays that help explain why supplier diversity exists and why more and more large buying organizations are considering implementing these types of programs.

1. The Changing Demographics of the United States
The purchasing power of minorities and women is experiencing exponential growth. Progressive and socially

responsible companies understand that to compete in today's global marketplace it is imperative to align their business operations and practices with these opportunities. Companies may choose to work with small and diverse-owned businesses to ensure that their supply chain is as diverse as their customer base. They understand the demographic shifts that are occurring and are acting accordingly with this awareness.

According to U.S. Census and Pew Research Center data, the minority population is expected to increase significantly over the next forty years, with the increase in those who reported their race as something other than white alone, specifically, those who reported their ethnicity as Hispanic or Latino.[1,2,3]

In the same report by the Pew Research Center, the Asian population has experienced the fastest rate of growth and is projected to triple their 2020 population numbers by the year 2060.[4]

Minority buying power is also growing. Nearly $1 out of every $5.75 of buying power in the US belongs to an African American, Asian American or Native American household.[5] According to the 2022 Annual Business Survey, approximately 1.2 million or 21 percent of employer firms in 2021 were minority-owned, 304,823 (5.2 percent) were Veteran-owned, and around 1.3 million (22 percent) were owned by women.[6]

With the largest population growth coming from the minority community and their projected increase in purchasing power, people from these communities should be customers to large businesses who could be buying goods

and services from them, helping the company's profits grow. If a corporation wants diverse-owned minority and other diverse firms to be their customers, then it might also be a good idea to support doing business with them so that they can hire employees which will give them the resources they need to buy more goods and services from their corporation. The cycle of the economy goes round and round. By increasing the number of people who can participate in driving the success of our country, there's an opportunity to improve the overall health of the economy for everyone.

One of the most promising economic trends is the increasing number of minorities and women who are attending college and earning advanced degrees.[7,8] Many of these students will go on to obtain senior-level and executive positions within corporate America and may become entrepreneurs themselves. These same students will likely be in support of supplier diversity and other pro-inclusion initiatives as they become the next generation of leaders.

2. Growing a Diverse Supply Base

Having access to an increasing supplier pool offers more options, can stimulate competition, inspire innovation, and offer diverse perspectives that can result in cost savings, revenue growth, and higher quality, thus adding to a company's overall competitive advantage.

3. Access to Emerging Markets

From a global brand perspective, supplier diversity allows

companies to penetrate inclusive communities, positioning themselves to be the company of choice for small and diverse-owned firms. Increasing visibility within and strengthening relationships among emerging markets can enable companies to broaden their customer base, grow market share, and increase revenue potential.

4. Customer Performance Expectations

Supplier diversity efforts can support a company's overall corporate strategy and allow the company to be in alignment and compliance with the expectations and goals of its customer base.

In today's world, many corporations are seeking to do business with suppliers whose values align to their own company's mission, goals, and values. Supplier diversity and diversity, equity, and inclusion (DEI) programs are two variables among many that companies are assessed on by their customers, on top of price, quality, customer service, sustainability, and delivery. As a prime supplier to the federal government, companies have a public responsibility to comply with Federal Acquisition Regulations[9] and state and local laws concerning the utilization of small businesses.

Commercial customers may also have similar requirements. Oftentimes, companies are required by law or by contract to track and report "spend and participation" to their customers, which include the dollars and percentage of dollars spent with small and diverse-owned businesses as well as the roster of outreach events the company has participated in (e.g., attendance at supplier diversity conferences and tradeshows), training and education events, developing and contributing to supplier develop-

ment, mentoring and capacity building programs, funding scholarships or grants to small and diverse-owned firms, and more.

5. Competitive Advantage

Being able to demonstrate a leadership position within supplier diversity can differentiate a company from its competitors. Supplier diversity can help sustain and build a company's corporate image, brand reputation, and loyalty as well as create shared value among its current and prospective customers.

6. Cost Efficiency

When companies open their supplier pool and periodically bid contracts, it allows them to check and verify that they are continuing to receive the best quality goods and services. It allows them to reassess if the price they are paying for a good or service remains competitive and in alignment with industry changes. It allows them to be exposed to different perspectives and perhaps innovations to better manage their operations or serve their customers. Finally, it also stimulates competition which can help companies control costs, and generate cost savings and cost avoidance.

7. Innovation

A diverse and inclusive supply base offers differing perspectives. This advantage can allow companies to win by leveraging experiences, talents, and viewpoints from a wider range of suppliers who may bring new ideas, approaches, and ways of thinking to tackle old problems and create new solutions.

8. Economic Impact

Supplier diversity programs have the unique ability to directly stimulate local and global economies. By doing business with diverse suppliers, a company can positively impact job creation, economic empowerment, development, and growth in the communities in which they operate.

Here are some key examples to consider:

Veterans' Spending Power

According to the National Veteran-Owned Business Association, one in five adults, or 22 million people nationwide, have served in the armed forces. With Veteran households spending 16 percent more overall than the average US household, the total spending power of the Veteran community exceeds $1.5 trillion annually.[10]

People with Disabilities' Spending Power

The American Institutes for Research reports that the total disposable income for working-age people with disabilities is about $490 billion. Given that people with disabilities are part of families and communities, this number more than doubles when you consider the spending of families of disabled people and the communities in which people with disabilities reside and do business.[11]

LGBTQ+ Spending Power

The LGBTQ+ community has a buying power of $917 billion. If all estimated earnings of LGBTQ+-owned businesses in America are projected, their contribution to the economy would exceed $1.7 trillion, according to the National Gay and Lesbian Chamber of Commerce.[12]

Women's Spending Power

Bankrate[13] reports that over 80 percent of purchases are made by women. 66 percent of consumer wealth will belong to women in the next decade.

African Americans' Spending Power

Combined spending by all Black households has increased five percent annually over the past two decades. It has outpaced the three percent growth rate of combined spending by white households.[14]

During the pandemic in 2020, African Americans' economic clout energized the US consumer market as never before. The buying power of African Americans rose to $1.6 trillion, or nine percent of the nation's total buying power.[15]

Latinx Spending Power

As consumers, Latinos represent a trillion-dollar market, and their spending power is rising. They are also the fastest-growing minority entrepreneurial group.[16]

3
DIVERSITY CERTIFICATIONS

What is a diversity certification, and do I need one?

The route to business ownership can be pursued in a few ways. One route a person could take is to create a business from scratch and build it from the ground up. Another is to buy an existing business or establish a partnership with a group of individuals to create or buy a business together. Some people become owners by inheriting a business from their parent or spouse or by becoming an owner another way.

The reason ownership becomes an important topic for supplier diversity is because of who owns the business, who operates the business, and who controls the business. Business ownership is a very important matter. Let's look at why. In America and around the world, we know that fraud exists. Supplier diversity is not exempt.

To ensure that the spirit and integrity of supplier diversity remains intact, and that the vendors defined as historically underutilized businesses (HUBs) in America are truly given the opportunity to compete for large government and commercial contracts, a process has been created and embedded into supplier diversity practices to

help buying organizations guarantee the authenticity of such firms: diversity certifications.

Diversity certifications were established to help companies and buying organizations ensure that the spirit of supplier diversity is being fully realized. Companies become corporate members of supplier diversity advocacy organizations to confirm that the small and diverse-owned businesses in their supply chain have diverse ownership, and that they are in fact doing business with actual diverse-owned firms.

These certifications are critical, as they allow companies to audit their supply base, verify the accuracy of diverse suppliers within their supply chain, and track dollars spent among these firms. Certifications also allow companies to measure and report their performance with their certified diverse suppliers to their executive leadership teams, customers, and other external stakeholders.

Doing business with diverse-owned firms, which have been certified by an accredited organization, is the gold standard and world-class practice within the supplier diversity community. A leading supplier diversity best practice calls for companies to only report certified diverse-owned spending within their program. As an example: if you are a minority or woman-owned firm that is not certified, you are ineligible to be tracked, counted, and included in the company's programs. Therefore, your firm may lessen your customer's ability to achieve their supplier diversity performance goals among their customers who often require certifications as evidence of compliance.

Types of Diversity Certifications

» Minority-owned certification from the National Minority Supplier Development Council

» Women-owned certification from the Women's Business Enterprise National Council

» LGBTQ+ -owned certification from the National LGBT Chamber of Commerce

» Veteran-owned certification from the National Veteran Business Development Council and the National Veteran-Owned Business Association

» Disability-owned certification from Disability:IN, National Veteran Business Development Council, and the National Veteran-Owned Business Association

Buying organizations follow the nationally established definitions for categories of diversity suppliers set by advocacy organizations. Each of these diversity categories has an advocacy organization, listed above, that manages a range of programs and services to help educate, train, develop, and market their members to large buying institutions. Some of their programs and services include:

» Reviewing diversity classification applications and approving or denying their certification status,

» Administering and managing their members' certifications and periodic renewals,

» Maintaining a database of their certified suppliers that allows large buying organizations to find them,

» Creating and hosting conferences, meetings, trade shows, and events to facilitate networking among their constituency base and buying entities.

Working in the supplier diversity space for twenty years, I come from the perspective that a company obtaining every diversity certification it was eligible for would add value not just to their business, but to their customer's supplier diversity reporting goals as well. This will help the company tell a more complete story of how their supplier diversity program is impacting the communities in which it operates.

How to Choose Diversity Certifications for Your Business

As a business owner, and based on the diversity categories you represent, you have the option to select which diversity certifications you might pursue. As a Black woman, I would seek to obtain both a minority and woman-owned business certification to identify my firm as such, as well as to help maximize my company's ability to support my customer's supplier diversity program.

I also encourage you to speak to your customers. Ask them which certifications they would like or need you to obtain to help them report their business with you to their clients. This will show how committed you are to being in

alignment with and supportive of their corporate supplier diversity goals.

INSIDER TIP

Early in my career, I was invited to meet with a marketing firm in New York that I came across at a Women's Business Enterprise National Council conference. After their capability presentation, viewing samples of their work, and touring their offices, the owner said she could contribute four certifications to our program—minority, woman, Veteran, and LGBTQ+.

She said she pursued every certification she was qualified for to support her customers and prospective customers. I loved her approach and enthusiasm for representing all of who she was and the various elements of her diversity story. I encourage you to pursue the certifications that make the most sense to you.

To learn more about the organizations that certify diverse-owned firms, the certification process, the benefits of these certifications from the perspective of diverse entrepreneurs and buying organizations, and what to expect after you obtain your diversity certification, please review the resources in the appendix.

4

HOW LARGE CORPORATIONS BUY

What do I need to know in order to step into the ring?

Large corporations buy goods and services in a similar way to how individuals might buy goods and services. They just buy them on a much larger scale than most people are accustomed to.

Think about your residence. Whether you own your home or rent it, there is a high likelihood that you've purchased goods and services for your household. If you're like me, you've purchased furniture, art, dinnerware, bedding, and groceries. You may have also purchased housekeeping, plumbing, or electrical services. So, technically you are the chief procurement officer of your household. You buy what you need when you need it.

As an analogy, let's use common household buying scenarios.

1. **You run out of groceries.** You have a need. So, you buy more from the grocery store that will have what you need.

2. **You want to reupholster your sofa**. You have a need. Since this is a non-typical purchase for you, you must research options, secure quotes for services, determine the best cost based on your budget, then select an upholsterer for your project.

3. **Your appliances are working in good order.** You do not have a need. You are not in the market nor interested in strolling the aisles for new appliances at Best Buy, nor researching appliance options online.

4. **Your teenager mows your lawn.** You do not have a need. You are not researching lawn care providers now, but once your teen moves out of the house or takes another job, you may be in the market to hire a lawn care firm.

The common thread to these scenarios was an identification of a genuine need.

So just like you being the chief procurement officer for your home, a chief procurement officer and the heads of the departments inside a large corporation start their purchasing journey by determining exactly what they need and then moving forward with the purchasing process.

The sourcing process that many companies use is the widely known *A.T. Kearney 7-Step Strategic Sourcing Process*[17] listed here:

1. Profile the Category

2. Supply Market Analysis

3. Develop a Strategic Sourcing Strategy

4. Select the Strategic Sourcing Process

5. Negotiate with and Select Suppliers

6. Implementation and Integration

7. Benchmarking

You may also find it useful to see how other companies, The Purchasing Procurement Center[18] and Simfoni[19], define and illustrate different types of sourcing and their accompanying strategies.

Centralized and Decentralized Procurement

Another thing to keep in mind is who inside the company will complete the purchase? An individual employee or someone from the sourcing team?

For centralized procurement, the purchasing or sourcing team, typically at company headquarters, manages all purchasing responsibilities. When the act of purchasing occurs at the business unit level, or in varied locations, this is considered decentralized procurement. If this is the case, then any authorized employee of the company may make purchases.

Whether a company uses a centralized or decentralized model, supplier diversity is integrated into both processes.

Key Roles: Supplier Diversity Professional and Strategic Sourcing Manager

The roles of a supplier diversity professional and a strategic sourcing manager are different, although they may work

together in some organizations. Here's an overview of each role, edited from the AI-generated response to my query from ChatGPT[20]:

Supplier Diversity Professional

The primary role of a supplier diversity professional is to promote and facilitate the inclusion of diverse suppliers in the supply chain. This may involve identifying qualified diverse suppliers, engaging with them to understand their capabilities and needs, advocating for their inclusion in procurement processes, and measuring and reporting on the organization's supplier diversity efforts. The supplier diversity professional may also collaborate with internal stakeholders, such as procurement teams and business units, to develop and implement strategies for increasing supplier diversity.

Strategic Sourcing Manager

The primary role of a strategic sourcing manager is to develop and execute sourcing strategies that enable the organization to get the goods and services it needs at the best possible value. This may involve analyzing spending patterns, identifying sourcing opportunities, negotiating with suppliers, and developing contracts and service level agreements. The strategic sourcing manager may also be responsible for managing supplier relationships, monitoring supplier performance, and ensuring compliance with procurement policies and regulations.

◆ ◆ ◆

In summary, while the supplier diversity professional focuses on promoting and facilitating supplier diversity, the strategic sourcing manager focuses on optimizing the procurement process to get the best value for the organization. However, both roles are critical to ensuring a diverse and inclusive supply chain that supports the organization's goals and objectives.

Internal Reporting Lines

The supplier diversity team traditionally reports to the chief procurement officer within a supply chain management or purchasing division. However, some supplier diversity teams report to the chief diversity officer, chief financial officer, or to corporate strategy.

A best practice traditional supplier diversity infrastructure includes:

- » Vice President or Director, Supplier Diversity
- » Manager, Supplier Diversity
- » Supplier Diversity Analyst
- » Supplier Diversity Coordinator

Companies may add more team members and resources based on their size, strategy, their purchasing spend, and the complexity of the goods and services they procure. However, be aware that it is not uncommon to see a one-person supplier diversity team.

5

HOW TO MARKET TO BUYING ORGANIZATIONS

What's the best way to get the attention of these big companies?

Always Be Prepared

Every business, large or small, must go out, hit the streets, and conduct new business development work to successfully identify clients, pitch to them, and win contracts. It's a never-ending cycle and it can take many years to land a contract from a company you've been courting for what may feel like ages.

Each business wants to reduce this courting process and secure a contract quickly. While that's an admirable goal to have and it helps to keep you inspired, there are a few key elements of marketing that small and diverse entrepreneurs must not overlook on the path to success:

- » Know Your Market
- » Know Your Buyer
- » Know How to Sustain Your Business

Know Your Market

It means knowing who you intend to sell to and the factors that would interest them in your company's products and services. This is pure market intelligence.

Some steps which might help you know your market include:

Step 1

> » Create a list of top industries you believe your company can best provide value-added solutions.

Step 2

> » Prioritize your list.

Step 3

> » Repeat this process to identify the top companies you believe you could best serve.

Step 4

> » Prioritize your list.

Step 5

> » Based on your rank order results, initiate your market research plan.

INSIDER TIP

One of the mistakes I see diverse businesses make is believing that every company is their customer. This is why I want you to complete this exercise and conduct a deeper analysis to identify the profile of your preferred customer. I want you to be very mindful about the time you spend marketing yourself to the right companies.

Based on the companies and industries you identified, think about how you can increase your knowledge and understanding of the companies and the industries in which they operate. Then seek to become a company and industry expert.

From your targeted list of prospective customers, research their company websites and become their ultimate fans. Review their annual reports, their corporate social responsibility report, press releases, radio, and TV news coverage.

Review their social media sites. Like and follow their pages to keep abreast of internal and external factors that are impacting their business. Be able to talk their talk and demonstrate a shared understanding of what is happening in their space.

A Tale of Two Approaches: A Case Study

The COVID-19 pandemic had a profound impact on the U.S. aviation industry. Passenger traffic in April 2020 was 96 percent lower than April 2019 and stayed 60 percent below 2019 levels in 2020.[21] During this time, it was widely publicized on nearly every morning, afternoon, and evening newscast that the airline industry was operating at the most reduced levels since the 9/11 terrorist attacks.

Due to this drastic and sudden shift in customer demand, the airlines developed the most aggressive employee packages to immediately reduce their workforce to align with the new reality of reduced customers, reduced operations, reduced revenue, and a reduced need to buy their traditional goods and services. At the same time, the safety and global cleanliness standards and demand for new goods and service needs, such as Personal Protection Equipment (PPE) and cleaning supplies, were rising.

Meanwhile, some diverse-owned businesses who understood the realities facing the airlines recognized an opportunity to help during this global crisis and immediately reached out to sell cleaning products and PPE supplies to the airlines to positively impact their business needs and operations during this critical time. These suppliers were urgently needed and very helpful in supporting the business.

On the other hand, some diverse-owned staffing companies began contacting the airlines, feverishly trying to sell staffing services to expand the airlines' employee base. This was at a time when most airlines were trying to save their companies, de-risk their operations, and

substantially reduce their workforce and labor expenses due to the unplanned and unprecedented drop in their business during the pandemic. These suppliers were less helpful, even serving as a distraction, and demonstrated a lack of understanding of their prospective customers' business realities.

Based on this example, where would you want your business to fall? How would you want your company to be remembered by the supplier diversity and strategic sourcing managers who were struggling to address their company's shifting needs brought on by this global crisis?

◆ ◆ ◆

Do a search on the industries your prospective customers serve or ask someone in the industry what trade reports or industry associations they should follow. Research these reports to gain a better understanding of the industry— what's working, what's not, what their needs are—and try to get a general understanding of current and forecasted trends that may positively or negatively impact their business. Doing your research will give you the expert insights you need to differentiate yourself and your firm when talking to your prospects.

Another strategic way to differentiate your business is to be their customer and experience their products first-hand. By having direct knowledge of your target companies' products and services, you'll have the benefit of tailoring your conversation towards your personal experience. You can speak to what you learned, maybe identify one of their

blind spots, and recommend an innovative approach that may differentiate your firm from others.

Finally, consider joining the professional organizations your customers belong to. This will advance your knowledge of the market and allow you to network and build relationships with employees who may be members of the same organizations.

These insider tips can give you access to a richer base of knowledge of your target companies and the environmental and economic factors that impact their business. Plus, with these insights, you can achieve a greater competitive advantage over your competition that can help you strategically and intentionally align your firm as a problem solver that can help your prospective customers achieve their goals.

Know Your Buyer

This means knowing what they buy, how they buy, and when they buy.

Each company, large or small, has a strategic sourcing process (as we covered in chapter four) that they deploy when they have made the decision to initiate a formal RFP—a questionnaire that prospective suppliers must complete to demonstrate their ability to supply the goods and services requested.

INSIDER TIP

*Tips to Navigate the Request for Information/
Request for Quotation/Request for Proposal
(RFI/Q/P) process, also called RFx*

*When completing an RFx, read it fully to know what's
being asked. Fully understand what the company
wants and make sure your company can deliver
upon its commitments.*

*Answer every question, in detail and exactly in the
manner being requested, even if you don't think it's
relevant. They wouldn't have asked if they didn't
feel it's important.*

*Use a spelling and grammar tool, and ask others to
read the response for clarity, accuracy, and anything
else you may have missed. A gap in these areas might
suggest a lack of attention to detail.*

*Make sure your responses are polished and look
professional. Presentations that are poorly laid out or
challenging to read can distract from excellent content.*

In chapter four, I explained how large companies buy and their cycle for buying so you know how best to market yourself to them and how best to negotiate a meeting with key decision-makers. From the intel you learn during your market research, you should have a good sense of what your target customer buys. It's more difficult to know how and when they buy, sometimes even for those on the sourcing team, but if your goods or services align with a season or other industry procurement cycle, this information could be to your advantage.

Understanding what, how, and when they buy can help explain why a buyer may or may not entertain a cold call or a meeting with you. As stated in the chief procurement officer story in chapter four, oftentimes, when you approach a company to sell to them, you may be surprised or disappointed that you cannot land a meeting. This may be because of a few factors, such as:

» The goods or services you sell do not align with the company's current purchasing goals and priorities.

» The buyer for your goods/services may be working on another deal in a different commodity/service category that represents a higher priority for the company.

» The buyer may be working on an outsourcing or supplier consolidation strategy that might increase or reduce prospective supplier opportunities.

» The buyer may be redeployed to work on a special project for the company, and so is not currently sourcing suppliers.

» The buyer may be under crisis—managing a supply and demand issue, pricing adjustments, or several other variables that could go wrong in a supply chain.

» The buyer may be mentoring or coaching another supplier.

» There may not be a buyer at the time of your inquiry because the position at the company is open.

The fact is, large corporations move at their own pace and on their own terms based on their needs, priorities, and timing. There are a multitude of reasons why you may have gotten a "no" at that moment. The challenge is that you can't always know when a company is buying the types of goods and services you sell. And to be honest, there are many occasions where a company decides to make a purchase on demand based on an urgent or emerging business need that was not previously identified. It may be difficult to predict in advance what a company is buying and when they'll need it. Their "no" does not always mean it is a "no forever," so continue to market and promote your business to your target customers and make sure you actively listen to their rationale for a "yes" or a "no." Follow up with them based on their direction and guidance to you.

The key point to understand here is that the supplier diversity and strategic sourcing and purchasing decision-maker's number one priority is to source the goods and services that represent the most critical and active needs of the company. And that is determined by divisional leaders, by the company's supply chain management leadership team, and c-suite executives who approve the budgets for their teams to proceed.

That's why knowing your market, networking with buying and supplier diversity professionals, and making a positive impression ahead of need is critical to help you remain top of mind for when needs change and opportunities exist.

Besides the goods and services your companies provide, buyers are also looking for other qualities including:

Supplier Qualities	
Financial Health	Brand Value
Insurance	Work Environment and Safety Standards
Scale/Volume	Continuity of Supply
Industry Experience	Environmental and Sustainability Plan
Certifications	DEI and Supplier Diversity Plans
Quality Standards and Protocols	Tier 2 Supplier Diversity Compliance

Know How to Sustain Your Business

So, you've completed your market research, you've participated in a RFP, and you've earned a contract. Congratulations! However, your sales process is still not complete; it's simply transitioning to a new phase.

After the Win: How to Sustain Your Contract and Build on the Opportunity

After you've won the business, you now need to continue to build your relationship with your customer and work to ensure that you continue to maintain your contract.

Here are some of the ways you can do this:

» **Performance** – Supplier scorecards and business review meetings are tools companies use to measure the performance of their suppliers. You can utilize these opportunities, too, as feedback to achieve your ongoing supplier performance and delivery of service goals. Look at these evaluative tools to continue to learn about the business and be on the lookout for expansion of service opportunities. By continuing to deliver innovative ideas, you'll be demonstrating ongoing value to your customer.

» **Move from a Transactional Supplier to a Strategic Supplier Partner** – Go above and beyond to deliver value for your customer, be reliable, and become indispensable.

» **Go Beyond the Delivery of Service** – Look for ways to provide innovation, cost savings, and supplier diversity solutions. Share what you are doing as a business to support your local communities (e.g., sponsoring Boys and Girls Clubs, donations to schools or other civic organizations, etc.). Keep your client aware of new wins (e.g., expanding your business, buying a new business, earning a major client, or adding a new executive to your team).

» **Broaden Your Network** – Leverage your supplier diversity resource or the strategic sourcing manager you work with. Build relationships with leaders across other divisions with a goal towards securing new opportunities.

INSIDER TIP
*More about Supplier Scorecards
and Business Review Meetings*

*Some corporate supply chains host annual or periodic
business review meetings with their suppliers to
monitor their performance, maintain relationships,
ensure that suppliers remain aware of the company's
priorities and goals, and that their suppliers are
achieving those goals and delivering results.*

*As a supplier, you can negotiate with your buyer
on which assessment elements you would like your
company to be evaluated on based on the goods
and services you provide. Some considerations include:*

*Quality
Safety
Delivery
Customer Service
Responsiveness
Value Creation
Sustainability
Supplier Diversity (of your own company)
Risk (how much risk you may impose on your
customer or your customer's business)*

In summary, when negotiating access to large corporate buying organizations, be prepared to do your homework:

- » Know Your Market
- » Know Your Buyer
- » Know How to Sustain Your Business

By leveraging this approach, you will be able to position your firm to successfully negotiate from a stronger position.

6

ESSENTIAL MARKETING TOOLS

What's the best investment of my limited time and resources to get a buyer's attention?

Marketing to supplier diversity and strategic sourcing professionals can be an involved and lengthy process. Suppliers have reached out to me in a myriad of ways. Below are some of the top trends and recommendations I see in the supplier diversity networking space that you may want to lean into or avoid. We'll start with making the most of your online tools.

Company Website: Your Digital Headquarters

When I think about the essential marketing tools that are necessary for small and diverse businesses to market themselves to supplier diversity and purchasing professionals, the most critical tool that comes to mind for me is your company website.

Think back to your own purchasing habits, as we discussed in chapter four, with you being the chief procurement officer of your household. You make the decisions on what you buy, how you buy, when you buy, and where you buy, right? For example, if you and your family

are on vacation and you're in a country or a city where you've never been, how do you know which restaurant to go to? Besides working with the hotel concierge, questions you may consider include whether the restaurant is open, if it has the type of cuisine your family loves, or if you need directions.

These are the same types of concerns we have from a corporate procurement perspective. And in our case, we need to be sure you are a legitimate business. Just as most consumers will check the internet first, so do many buyers and supplier diversity personnel. In my role as a supplier diversity practitioner, my primary source for information is a prospective supplier's website.

Homepage

The first thing that I pay attention to is the organization and structure of your homepage. It's essentially your company's front door and my first introduction to getting to know your business. It's where I first determine if you can provide goods, services, and solutions to my company.

Having a short, concise, well-organized, and well-structured website that is uncluttered, easy to read, and quick to navigate makes it easy for me to go through the process I need to learn about your company and understand your capabilities. It's one way I assess if your company should be shortlisted and forwarded to the buyer or department leader who has the direct authority to determine which suppliers to include in an RFx and ultimately which supplier we will use.

If I go to your website and I can't quickly understand

how you can help my company, you've lost me, especially if I still have twenty or more companies to assess. I'm not going to look any further because you haven't done your job to give me the information I need in an organized manner or to inspire me to want to learn more and further explore what type of alignment or synergies may exist between our businesses.

For me, the most important pages on your website are the About Us and the Products and Services tabs.

About Us and Products and Services Page
In the About Us section, I only need to see about three to five sentences, or a brief bulleted list, that allows me to easily understand what industry you're in, what products you sell, and how you could help my company. If you have a complex service, then by all means add more sentences and bullets. I then move on to the next critical page, Products and Services. This is where you provide a little more depth, yet still a high-level overview of your company's core products and services.

Case Studies
Case studies, especially those that permit you to feature your customer's name on your website, allow me to quickly learn about the customers you've worked with. They are a great way to demonstrate that you are qualified and able to do the work a company needs and may be hiring you to do. I can browse the industries those companies are in, what problem they had, what your solution was, and the results they achieved from working with you. Who knows, I may

even read a case study that demonstrated how you solved the exact problem my company is currently experiencing. This is an easy way for me to want to move you forward in my research and referral process.

Good case studies tell a compelling story using data that clearly identifies a problem and how your company solved it, detailing the results gained in that solution. The case study conveys, in narrative form accompanied by verifiable facts and testimonials, the positive impact your products or services made on the customer's business. Include photos and graphics!

I have a marketing background and I used to manage a case studies program for a company I previously worked for. We did photo shoots to show real world applications of how my company's products were being used in actual corporate environments to visually tell a story. With photos, graphics, and words that demonstrated our products in action for our customers, we conveyed the problems we solved for them and the results they achieved from their product purchase. The case study can be created in a print, digital, or video format.

A good case study can also be featured in a presentation or even as an article for an industry publication. You can find numerous tutorials and templates online to learn how to create a persuasive case study, along with examples to help inspire you. Check out these examples: Pandadoc blog[22], Hubspot blog2[3], and Herman Miller Mexico City, Mexico[24].

Testimonials

Testimonials are another way to showcase how you've been an excellent supplier to others and is a good way to establish trust in your company. Additionally, sharing your client list or industries you've worked in provides further credibility. This information could specifically relate to my interests (e.g., if you've worked with companies in my industry or with my competitors or peers).

Have you ever been to a restaurant and on their menu they shared a story about how that restaurant came into being? I love when restaurants do that, and I take the time to read them. I would encourage you to feature on your website your own origin story about how you started your business.

Add this to your About Us section to share your story relating to why you decided to become an entrepreneur. What was so exciting about your industry that led you to take a chance to be an entrepreneur? What expertise do you have that makes you an authority on the subject? If yours is a family-owned business, you could share a story of how your business came into being. Talk about your family founder's original idea and how you're carrying on their legacy. Your narrative is one of your unique differentiators because your story is unique to you, and what you've built. And your story will be memorable to your readers.

It's very important for you to convince purchasing and supplier diversity professionals to choose to do business with your company over the many other qualified diverse suppliers around the world. Explain your value proposition

and your unique differentiator. Call those things out. You may be surprised that when you include keywords, values, or descriptors that align with your prospective customer's values (for example, "Quality, Service, and Sustainability"), it can demonstrate why they should be doing business with you.

Contact Us

Lastly, a call to action would inspire your prospects to act. Remember to include a contact us button. You would be surprised to learn that many websites make it very difficult to find out how to reach someone. When I am working on a project and I need to turn around referrals quickly, I often will pick up the phone and start contacting firms, then ultimately get into the game of phone tag. Or surprisingly, never even get a response back. Yeah, that happens. A company misses out on business if it doesn't provide multiple contact methods such as email, phone, or chat, so give easy options to connect.

You want to know the absolute best thing about having a website? Your website link can be quickly and easily shared and forwarded to others. How's that for service and sending referrals quickly? A simple web address also reduces the need to send large PDFs and documents that either don't open or can't make it through a large company's firewall.

Product Portfolio: Digital Gallery

When your business' products and services can best be told using photography or video, use that. When I meet

architecture and design firms, construction companies, marketing agencies, learning development companies, I want them to "Show me the visuals!" Bring your laptop or iPad to share visuals at supplier diversity conferences and make sure you add a Product Portfolio or Gallery tab on your website that features what you can do. Seeing is believing.

NAICS Code: Defining Your Industry Segment

One way to help supplier diversity professionals find your company quickly when using advocacy organization databases is to include your North American Industry Classification System, or NAICS code[25], on your profile to highlight your business type. The NAICS code is essential as it defines the type of business you have and allows us to research and identify firms that most closely align to our sourcing needs in a timely manner. Sorting by keyword can take longer and yield a greater number of supplier referrals, but oftentimes some of the suppliers found don't align with the scope of work, which makes the research and identification process more difficult and time-consuming. The NAICS code can help streamline our research efforts.

For businesses with multiple service categories, when creating your supplier profile in the advocacy organization databases, whenever possible feature three to five codes that most closely align to your company's core business operations. Rethink the codes you use and only add in supplemental codes that align to your business. For instance, when doing research for plastic injection molding firms, I've come across window providers, which

wasn't helpful, and clearly a misalignment to my sourcing needs.

Corporate Supplier Registration Portal: A Tedious, but Essential Prerequisite

Supplier registration portals get a bad rap, and for good reason. Portals are online supplier profile management systems that allow suppliers to register their firm with hundreds of companies they're interested in being a supplier for. Add a photo, logo, and a summary about your firm and its capabilities in hopes that the supplier diversity and buying staff at each company they register with will include them in sourcing RFPs with the goal to become one of their suppliers.

Most prospective suppliers feel registration portals are a huge waste of time and not necessary. Prospects feel they spend hours registering in hundreds of portals and that once their profile is submitted, they will immediately receive a call, an invitation to bid on a project, or a meeting invitation. Basically, many prospective suppliers feel like these portals are a black hole where their company profile and business information go to die.

As a person who uses registration portals and has instructed suppliers to register with my company's portal, I can certainly empathize, as I can only imagine how much peoplepower and time is required to create vendor profile, after vendor profile, after vendor profile, in potentially hundreds of prospective supplier databases. And I can imagine how you, as a small or diverse-owned business, could better use that time and people resources elsewhere.

Acknowledging this, let me show you the other side of the dreaded supplier registration portal. Let's look at the point of view of a corporate supplier diversity professional two-person team.

Why We Ask You to Register in the Portal

Behind the Scenes of a Two-Person Supplier Diversity Team

Samara and Julio work at a company that has 20,000 employees around the world and six core supply chain purchasing areas.

Conservatively, they have a weekly incoming volume of 100 prospective supplier queries, with about twenty calls per day coming into their office. They average roughly 400 queries each month, for a total of about 4,800 calls or emails per year.

If each call or email response averages fifteen minutes, that equates to five hours of their eight-hour workday, or 62.5 percent of their workday spent handling queries by email or phone.

With these incoming call/email volumes, it would leave Julio and Samara with only three hours or 37.5 percent of their workday to manage their other roles and responsibilities.

In a week's time, they will have spent twenty-five out of forty hours/week processing queries of prospective suppliers' phone calls and emails.

This would leave very little time for Samara and Julio to fully develop and manage a corporate supplier diversity program which includes building relationships with their internal spend decision-makers, creating supplier diversity training tools for internal colleagues and external prospective suppliers, promoting the supplier diversity policy and resources available to engage colleagues in this work, and more.

◆ ◆ ◆

When you see how supplier diversity cold calls and queries are managed through this context, I hope it's a little more palatable to understand why large corporations use supplier registration portals to help better manage the volume of queries. Does it help you understand why you may receive slow to no supplier diversity email and phone responses? Adding to this delay is the fact that many anxious suppliers will send the same email or phone call query multiple times within a two to three-week timeframe, so the challenge of responding to firms gets exacerbated with a seemingly never-ending loop of trying to manage the volume of diverse supplier queries.

I'm not saying this is right, nor that with advancing technology it will continue to be an issue, but I want to share this broader context with you in hopes that you'll

have less of a tendency to take a slow or no response personally. More supplier diversity team members, staffed supplier diversity call centers, chat bots, and other technology could be solutions. However, with budget and staff constraints, the tedious task of submitting supplier portal information will likely continue to be a challenge for some time.

Another thing to consider is that people come and go from large corporations. The relationship and visibility you build with one sourcing manager could be reduced if they leave the company. If your company's profile is included in the company's supplier diversity portal, your profile will continue to be visible regardless of which buyer is managing your commodity.

Social Media: Staying in Tune with the Evolution of Digital Communications

I have a confession to make. I'm not the biggest user of social media. I do have LinkedIn, Facebook, and Instagram accounts, but I use each of them sparingly and for different reasons.

I use LinkedIn to build out my personal network as it relates to job opportunities, professional development, and career growth. I also use it to remain connected with current and past co-workers, and current and prospective suppliers where I've built an established relationship over the years. It is not the tool I use to mine for prospective suppliers because there are better, more efficient tools for me to use, including:

» My company's supplier registration portal

» Supplier diversity organizations that certify diverse suppliers or maintain national databases: National Minority Supplier Development Council, Women's Business Enterprise National Council, National LGBT Chamber of Commerce, Disability:IN, National Veteran Business Development Council, National Veteran-Owned Business Association, U.S. Small Business Administration

» Supplier diversity outreach and events

» My supplier diversity peer network

Unless we've met on a few occasions and we've made a solid connection, then for me at least, you would be better served using one of the resources above as your first outreach. The supplier diversity advocacy organization databases and corporate supplier registration portals are tools specifically designed and created for supplier diversity leaders to connect with small and diverse-owned firms. If you are a supplier who is certified with one of the organizations above, attends supplier diversity conferences, meetings, and events, I would strongly encourage you to maximize the use of these tools, and keep your profile updated.

Each supplier diversity and purchasing professional has their own preferences for how to connect, so follow their lead based on their corporate website and by how

engaged they are to prospective cold call connections on their personal social media platforms. In contrast, if you have a job, professional or business development, career growth or speaking opportunity for me personally, then contacting me by LinkedIn is the way to go.

In terms of your own company's social media strategy, I recommend that you create an online presence that best aligns with your company's marketing strategy and who you are trying to reach. A marketing consultant, your mentor or advisory board, small business coach, or your peer network can advise you about the most suitable social media platforms to market your company. Platforms that I see small businesses use most often are LinkedIn, Facebook, Instagram, X, and YouTube. Using these tools are a great way to promote your company.

Diversity Certification:
An Added Value and Key Differentiator

In chapter three, I spoke about the benefits of certification. Here I recommend that you feature your diversity certification on all your marketing collateral, both electronic and print materials. It's another great way for you to market yourself to companies who are seeking to do business with certified diverse-owned firms. It allows them to identify you quickly and easily as such.

User-Friendly Technology: Make it Easy to Connect

In addition to websites and supplier registration portals, consider utilizing Google Docs, Dropbox, or other large file sharing platforms. I recommend sending links to large

files that can be viewed and opened without downloading. In my experience, there have been many times when prospective businesses have sent large attachments to me that I had to delete because the files were too large to get through our corporate firewall. Or I couldn't download a file because it violated corporate IT policies. These were missed opportunities for the prospective business, as well as for our corporation, and another reason why leveraging the supplier diversity advocacy organization databases and/or corporate supplier registration portals can be better suited for uploading and storing your files.

Not all marketing tools exist in digital spaces. Print and face-to-face approaches are extremely effective complementary strategies.

Business Cards: When and How to Use Them

It's been said that business cards[26] were first created in fifteenth century China and used to describe how awesome, interesting, or important an individual was, essentially for self-promotion. By the seventeenth century in Europe, they became playing card-sized notices distributed by the elite to signify their arrival.

In the twenty-first century, business cards remain a traditional tool to communicate who you are, the company you represent, your office locations, and contact details including your phone numbers, email address, website, professionally relevant credentials, and social media handles.

Some business cards may even include a company's core values, a listing of their products and services, and

feature braille or a second language translation. From my perspective, the business card is an art form of communication that remains relevant and useful today. In the supplier diversity space, they are still regularly used and traded at conferences, meetings, and events.

In my office, I have piles of business cards that represent people I've connected with at the various conferences I attend each year. Sometimes when I think about a particular supplier I met at an event, I can usually remember at which event I met them, and if I don't remember their name or their company name, I'll often go through my stacks of cards to see if their card could trigger my memory.

For example, I attended a conference where I met a gentleman who had a simple, clean, modern, and memorable orange and white business card. With my background in marketing, looking at logos and brand identity designs have become second nature to me, and I find them fun and intriguing. His card stood out and was a unique differentiator for me. His logo flashed in my mind when an opportunity arose at my company where his product aligned with our immediate sourcing need. I sorted through the piles of business cards on my desk and was able to find his card. I reached out to him and within a few months he earned a half-million-dollar contract, introductions to other leaders within the company, and generated additional business from that one encounter and stand-out business card shared at a conference. That is one example where a business card clinched a deal.

The green movement has led some people to adopt more sustainable standards, like using recycled paper products or creating and sharing digital business cards

and QR codes. Some individuals at events opt to take a photo of a person's business card instead of taking the card itself.

Yet, how and when to use business cards has been a source of conflict and confusion for small and diverse-owned businesses and buying professionals for years. Case in point: Supplier diversity leaders attend dozens of conferences, meetings, and events. In one year alone, I could easily have met and received business cards from 500 entrepreneurs with a conservative estimate of fifty connections made at ten events. Of those 500 connections, conservatively, ten percent or fifty diverse-owned businesses may participate in a RFP from my company.

Supplier diversity people get inundated with business cards. But if you really consider the role of a supplier diversity professional and the time spent on cold calls and networking, going back to the Samara and Julio example above, it's clear that the bulk of our work is spent outside of networking. I'd conservatively estimate that the networking component accounts for twenty percent of our role. Yet there is a misperception among diverse businesses that our role is ninety percent networking. That is understandable, because as prospective suppliers, you primarily see us in our most visible role as corporate liaisons at trade shows and conferences, when we're delivering speeches or facilitating workshops and other training events.

What's less visible to prospective suppliers is the time spent creating and implementing the supplier diversity strategic plan, socializing the plan among internal and external stakeholders, building networks and relationships with colleagues who buy goods and services at the company, and reminding them to ensure their sourcing projects are supplier inclusive every single time.

Prospective suppliers may not see us when we're at our desk researching diverse-owned companies across the multiple supplier diversity databases, or the time it takes to review twenty or so websites for any given sourcing project. We're not visible to you when we're engaging with diverse suppliers in goods and service areas that are different from your own. You may not see us when we're working with our analytics team to measure and report our supplier diversity performance to internal and external stakeholders, and ensuring our data and the integrity of our data is sound.

You don't know when we're working with our corporate communications team to draft policy language or standard operating procedures, creating presentations and presenting to c-suite leaders and our colleagues, or strategizing other communications to promote and embed supplier diversity within the DNA of our companies. There is a lot of work that goes on behind the scenes, more than what meets the proverbial eye.

INSIDER TIP
It's Not Personal

The fact of business card exchanges is that a lot of supplier diversity personnel don't like to give out their business cards too generously at conferences because many suppliers don't use these cards wisely when received. Some suppliers over call, over email, and can, simply put, be a nuisance by overwhelmingly contacting supplier diversity and strategic sourcing managers. The volume of cold call emails we receive on a daily or weekly basis is truly impossible to manage.

For this reason, a supplier diversity leader may choose to share their business card only with companies where a true opportunity exists in the short run. For firms who are certified with one or more of the supplier diversity advocacy organizations I previously mentioned, our contact details can be found in their databases.

If you had a conversation with a supplier diversity person and there doesn't seem to be any opportunity at the present time (e.g., a contract is in place and not up for renewal) or they have a diverse supplier currently providing goods and services to them, you may instead choose to register your business in their portal and plan to connect with them at future events.

It may be difficult, but don't feel bad or offended if the offer to share business cards is not accepted. Accept the response and move on to other companies where there may be more synergies and greater opportunities to win a contract.

But fear not; we are a resourceful bunch! Be aware that supplier diversity professionals have access to several databases to help us locate diverse firms. We also have access to our peers who are eager and willing to share diverse supplier referrals.

Be assured that when we need you, we know how to find you and will reach out accordingly.

I always tell supplier prospects that if I call you, it means I have an active project. I am seeking a firm like yours, and I need to be able to promptly share referrals with my colleagues. So, be ready to respond and engage when that call comes!

Company Profile: The One-Pager

Supplier diversity and sourcing professionals may be challenged with the volume of prospective supplier queries we need to manage. To help expedite your ability to communicate who you are and what you do, I recommend creating a one-page supplier profile.

This profile provides a high-level overview of what we need to know about your business within the space of a standard US letter-sized document. The one-pagers can be used as PDFs sent via email or featured as one of the pages on your website. See an example template below.

Business & Contact Information	
Business Name	
Primary Owner Name	
Primary Owner Title	
Primary Owner Email	
Primary Owner Phone #	
Primary Contact Name	
Primary Contact Title	
Primary Contact Email	
Primary Contact Phone #	
Address	
Email	
Website	

Company Overview	
Provide a brief qualitative summary of your business.	
Year Established	
# of Employees	
NAICS Code(s)	
Please provide NAICS code(s) that align to your business in rank order based on the percent of your company's business.	
Annual Sales	$
Market	International, National, Regional (Optional: list specific countries, states, cities, or feature a map on your website that features the locations you serve.)
Legal Structure	Corporation, LLC, Sole Proprietor, Other
Certification Information	
Certifying Agency	Name of Agency
Certification Type	Indicate your diversity classification: small, minority, women, Veteran, LGBTQ+, disability-owned, other

Minority Group, if applicable	Indicate if African American/Black, Asian Indian, Asian Pacific, Hispanic/Latin American, Native American
Certification Date	
Expiration Date	
Certification	Link to your certification
Certification #	

References

List three to five business references including: Company Name, Contact Name, Contact Phone #, Contact Email, Services you provide to them.

Company Promotion

Provide a link to supplemental promotional tools, if applicable—capability brochure, YouTube videos, etc.

Customer List: Your References

Sharing a list of customers and industries you've worked in helps to further validate the credibility of your firm. Whenever possible, share your list of customers on your website, one-pager, or add the list to a slide in a PowerPoint or other presentation to prospective clients.

**Sponsorships and Speaking Engagements:
Let Your Voice be Heard**

A strategic way to get your business and your brand in front of hundreds and possibly thousands of prospective customers is to sponsor a supplier diversity conference, meeting, or event. You could sponsor a workshop, the catering, name badges, tote bags, promotional items, or more. Oftentimes with sponsorships, a part of your entitlements—the value you will receive as a part of your sponsor package—will get you five minutes or so on the event agenda to provide remarks. And of course, you will use a portion of your five-minute time slot to provide a company overview and sell your business!

It's important to note that when negotiating your sponsorship package, you have the option to negotiate for an advertisement, commercial, speaker, exhibit booth, or some other item you would like for your participation. Speaking of speakers, another strategic way to be visible is to serve as a keynote speaker or panelist at a conference or workshop. Imagine your prospective customers sitting in the audience while you showcase your expertise in a compelling and carefree manner.

Think about how you would quantify the value from that one hour speaking engagement by showing up and helping others to be great by hearing lessons from you. Small and diverse-owned businesses are often sought out to speak and share stories about how they became successful, and how they managed or are managing through a challenging time. Your leadership and experience can help uplift and inspire the next generation of entrepreneurs.

Another way to let your voice be heard is to serve on a board of directors or a committee at your certifying supplier diversity advocacy organization, a local chamber of commerce, or an economic development group. As an entrepreneur, you have unique insights that can offer tremendous value to the future growth of your community by being involved. And you just may serve right alongside current and prospective customers.

Exhibit Booth: Showcasing Your Business

You decide that now is the time to sponsor an event. The event could be for a golf sponsorship you secured, at a local art, music, or community festival, at a national conference, or at some other event where you believe there will be enough foot traffic that may generate new leads for your firm. No matter the location, now is the time to place a spotlight on your business.

That spotlight could include a ten-by-ten custom-designed exhibit booth, one or two pop-up banners, or a table with a tabletop display. You may feature brochures, flyers, business cards, promotional products, and videos. Oh my! And your staff may be dressed to impress by donning your corporate branded apparel—from polo shirts, T-shirts, or button-downs to other fashionable looks that make you stand out and draw attendees to your booth.

Open House:
Inviting Your Target Customers to Come to You

Just as corporations attend supplier diversity conferences to connect with a large pool of prospective suppliers,

small and diverse businesses should consider the same approach to help you more efficiently market your firm to your target list of customers. One of my preferred methods is attendance at supplier-hosted open houses.

In real estate, when a house on the market is opened by the seller's agent for a specific amount of time, prospective buyers can look around. The same approach can be used by small and diverse-owned businesses to invite your target customers to your business operations. Using this approach, supplier diversity and buying staff can meet your team, learn more about your business, experience your product or service, meet your employees, customers, and more. These open houses can be conducted in-person or virtually.

I've attended open houses where businesses gave us a tour of their offices, warehouse, and manufacturing plant while hosting repeated capability presentations throughout the event. It doesn't have to be an expensive endeavor. Offering refreshments and light snacks may be your only expense. I've also been invited to hear a business owner speak on a panel or attend a training session to experience first-hand one of the course offerings of a training and development firm.

There is a myriad of creative and innovative ways to create a memorable experience to bring your prospects to you. One key benefit is that inviting in many prospective customers at once allows your prospects to bring in multiple people from their company. This helps you gain exposure to multiple contacts and decision-makers, generating a bandwagon effect as they see other companies interested in your products and services.

7

COMMUNICATING WITH PURCHASING PROFESSIONALS

What does successful contact with a company's supplier diversity and purchasing professionals look like?

The Communication Cycle

Connecting with people in a large corporate environment is like connecting with an individual person. Sometimes you'll resonate with people, sometimes you won't. The key is to take each encounter one step at a time and focus on the person you are speaking with and what information is most important to them. Try to convey how you can help them versus how they can help you.

Starting with the point of view of trying to add value to a corporate supplier diversity or purchasing professional could go a long way towards building a sustainable relationship that in time could be beneficial to you both.

Making Contact

Many companies provide information about their supplier diversity program and how to do business with them on their company website. They may provide instructions on

how to register with them, what goods and services they buy, what national or regional conferences they plan to attend that year, and a vehicle for you to upload your capability materials to them for future review and consideration. In some cases, although rare, some companies post staff names and contact information. That being the case, it's a good practice to follow these instructions first before reaching out to the company you're targeting. When you do reach out, inform your contact that you've already completed the steps they outlined.

This is important because people in large corporations come and go. In the best-case scenarios, we get promoted or take on new roles. So, you want to make sure that no matter who is responsible for procuring your goods or services, your profile will remain visible in their system to help the next person in that role find you.

If you decide to reach out to them by email, think about how you like to be approached, but also think about being direct, simple, and concise in your communications. Using me as an example, I happen to prefer communications by email, with a very brief introduction as to why you're reaching out to me and what action you'd like me to take in response to your communication.

The reason for this is that the email provides content that I can easily go back and reference. If we talk on the phone, more than likely, I'll ask you to email me what we discussed as a reminder.

Here's a quick template to use as a guide to outline your communication:

1. Your name, company name, products/services you provide.

2. What solutions you have for my company, along with global brands or other customers you do business with.

3. Share if you're a current/past supplier.

4. Your revenue if you can disclose it.

5. Your "Ask." What do you want me to do with this information?

Using this approach will help me to quickly assess your email and the steps I need to take to forward your information to the correct people who should receive and act on it. Remember, your website is my most critical marketing tool and it should be featured in this email.

Be mindful that everyone is different. You may meet some people who prefer phone calls or to be connected through social media, LinkedIn, or texts, so be open to changing your mode of communication according to their stated preferences. For example, if you were to contact me via LinkedIn, if I respond, I'd ask you to email me at my company's email address or my company's supplier diversity mailbox.

As shared in the previous chapter, hundreds of companies reach out to supplier diversity and purchasing professionals weekly. In addition to processing phone calls and responding to large volumes of email queries, we support large internal teams too. So sometimes it can take time before receiving a response. Reach out, then circle

back in a few weeks to check in if you get no response. Just like you, we're looking for a good match too.

INSIDER TIP
Know When Less is More

You may not like this, and I don't like having to say it again here, but it comes from a good place meant to give you an advantage. Many prospective suppliers have a reputation for being overly eager and, at times, desperate by over calling, over emailing, and essentially harassing, disrespecting, and unknowingly turning off corporate purchasing representatives.

Nine times out of ten, it's because they don't know or don't respect the supplier diversity engagement process at a given company. That is not always their fault, which is one of the reasons I wanted to write this book.

As mentioned in chapter six, companies who value supplier diversity experience large volumes of cold calls and may not have the staff nor infrastructure to manage the volume in a timely manner, thus their response time may be delayed.

Like you, supplier diversity and sourcing leaders must balance how they prioritize and manage their time in alignment with company goals and the priorities of the companies they represent. Prioritizing call backs and managing workloads and being mindful to not set unrealistic expectations for prospective suppliers is an ongoing challenge.

Supplier diversity leaders may focus their efforts first on connecting with those firms who have the highest likelihood of being able to provide a product, service, or solution where a true opportunity exists, or that will help their companies achieve their procurement and supplier diversity goals for any given year.

The reality is, and hopefully this is not you, some suppliers don't take "no" for an answer and feel entitled to have someone speak with them immediately, based on their terms, regardless of whether the company has a need for their goods or services.

Some have an erroneous expectation that we work for them versus the companies who pay our salary. Their approach can ultimately work against them. In this case, I suggest you work on your own balance—to be persistent, yet patient.

To help enlighten you on how diverse entrepreneurs may initiate their communication with a prospective buyer, I want to share a typical example using a fictional scenario.

Meet George

George is a certified minority-owned business owner of Geo Quality Audits, LLC, a company that advises small, medium, and large corporations on the standards and principles of the quality auditing process. He believes Golf Ball America (GBA), could use his services to ensure the quality of their product remains stable for years to come. Before reaching out directly to GBA, he conducts preliminary market research to determine if an alignment exists between their two companies. George takes the following actions:

Step 1: VISIT WEBSITE
» Review 'About Us'
» News
» Supply Chain and Supplier Diversity
Step 2: FOLLOW INSTRUCTIONS
» Complete supplier registration
Step 3: NETWORK
» Send email to confirm registration
» Create a networking plan
» Join organizations and/or committees

Step 1: George visits GBA's corporate website to learn more about the company. He reviews their About Us page to learn about the company's core business operations and the services they provide to their customers. He also reviews their corporate news page to understand the latest happenings at the company and within their industry. He visits their Supply Chain and Supplier Diversity pages to understand their supplier diversity program, supplier requirements, codes of conduct, and supplier registration process to determine if the company is a suitable prospective customer. He determines that it is.

Step 2: George follows the instructions GBA shared on their website to begin the journey of establishing a business relationship with them, with a goal of becoming a supplier to them in the next three to five years. George understands that courting a new prospective customer can be a lengthy process with GBA and plans to undertake a similar process later with other corporations he has decided to target.

Step 3: After George completes GBA's supplier registration procedures, he begins the direct networking process by emailing GBA's supplier diversity team to confirm with them that he has completed their supplier registration process. Next, he creates a networking plan to connect with the GBA team at a supplier diversity conference they will mutually attend, and he'll plan his follow-up communications after he's learned more about how they prefer to stay in touch with prospective firms. George notes that GBA's chief procurement officer serves on

a committee of a professional association to which he belongs, so he decides to join that committee too.

Cold Call Communications

When reaching out to corporate representatives for the first time, take a clue from David Currier and Jay Frost's book, Be Brief. Be Bright. Be Gone.[27]

> » ***Be Brief*** - Keep your sales presentations short and to the point. This goes for phone and face-to-face conversations too. Share only what's most critical for an introductory meeting.

> » ***Be Bright*** - Understand your product and its clinical context. Share what you sell and the value of your goods and services. Be prepared to answer questions.

> » ***Be Gone*** - Respect your customer's time. Tell your story in ten minutes or less; if they want more time or materials, they'll ask.

Here are a couple of fictional examples to help set the mood and tone of your email communications:

1. Cold Call Email Template

2. Cold Call Email Example

3. Follow-up Email Template

4. Follow up Email Example

Cold Call Email Template

Hello <u>First Name</u>,

My name is <u>Your Name</u>, <u>Title</u>, <u>Company</u>, a certified type of diversity-owned business classification. We provide <u>type of products and services</u> to <u>type of customer(s)</u> in <u>geographic location (local, regional, national, global)</u>.

I'm contacting you because I believe our type of service(s) could help <u>Target Customer Name</u> achieve the following business goals: <u>Goal A</u>, <u>Goal B</u>, <u>Goal C</u> <u>from your company's website</u> and contribute to your <u>type of supplier diversity</u> goal.

Our firm has been in business since <u>Year</u>. We have achieved type of results for our customers and look forward to delivering similar results with you.

Please visit our <u>website (add link)</u> to learn more about our firm and review case studies that demonstrate the solutions and results we provided to our customers.
Please advise when you'd like to schedule a meeting.

Sincerely,

<u>Your Name</u>
<u>Title</u>
<u>Company Name</u>

<u>Email address</u>
<u>Phone number</u>
<u>Link to website</u>
<u>Link to other relevant promotional materials</u>

Note: *Do not send large email attachments unless requested. Use your website as your primary sales tool. If more information is needed, you can follow up at their request.*

Cold Call Email Example

Hello Victoria,

My name is George Chesterton, CEO and Owner, Geo Quality Audits, LLC, a certified minority-owned business. We analyze quality systems and formalize plans to improve evaluation and control systems to small, medium, and large businesses in the US and Canada.

I'm contacting you because I believe our patent pending quality system could help Golf Ball America achieve the following business goals: assess current quality program, recommend enhanced quality action plan, reduce waste 30 percent by lowering material content and contribute to your minority-owned spend goal.

Our firm has been in business since 2000. We have achieved 95 percent improvement scores from our customers and look forward to delivering similar results with you.

Please visit our website (add link) to learn more about our firm and review case studies that demonstrate the solutions and results we provided to our customers.

Please advise when you'd like to schedule a meeting.

Sincerely,

George Chesterton
CEO and Owner
Geo Quality Audits, LLC
geoqa@xxxxx.com
xxx.xxx.xxxx
Geo QAxxxx.com (insert link)
Link to Business of the Year Award (insert link)

Follow-up Communications

When following up with someone you've previously met, have already presented to, or with whom you've established a good business rapport, stick to this rule of thumb: Be Brief. Be Bright. Be Gone. Additionally, ask yourself the following questions before sending an email or reaching out to them to reassess if your communication is timely, relevant, and needed, or if the discussion could be held at an alternate time or location.

For example, if a conference is taking place in the next month or so, plan to connect with them there. Ask yourself:

1. What is the reason and purpose for my email?

2. Am I providing new information, or information I've previously shared?

3. How will my communication add value to them?

4. Is this communication necessary?

5. Is this the right time to reconnect?

When you've asked yourself these questions, you're ready to craft your email.

Follow-up Email Template

Hello <u>Victoria</u>,

It was nice to meet you in person at the <u>name of event when</u>. As discussed, <u>reason and purpose for the email</u>.

I also wanted to share <u>new information</u> as I believe this could <u>type of value to them</u>.

Please advise when you'd like to schedule a meeting.

Sincerely,

<u>George Chesterton</u>
<u>CEO and Owner</u>

Geo Quality Audits, LLC
geoqa@xxxxx.com
xxx.xxx.xxxx
Geo QAxxxx.com (insert link)
Link to second promotional content, press release, article, etc. (if one is available) (insert link)

Follow-up Email Example

Hello Victoria,

It was nice to meet you in person at Acme Golf Manufacturers Council (AGMC) last October. As discussed, I'm following up with you after <enter timeframe of last communication—eg; one week, one month, one year> to continue our discussion and learn if the quality RFP is moving forward next year as planned.

I also wanted to share with you that we recently won a contract award with Great Beds Manufacturing, a leader in bedding, health, and wellness. They implemented our patent pending quality system three years ago and achieved incremental quality improvements during that time. This year, they achieved their quality goals which reduced waste by 70 percent. The largest waste reduction achievement in their company's history.

Please advise when you'd like to schedule a meeting to discuss a quality project with your team.

Sincerely,

George Chesterton
CEO and Owner
Geo Quality Audits, LLC
geoqa@xxxxx.com
xxx.xxx.xxxx
Geo QAxxxx.com (insert link)
Link to CEO talk at the National Quality Association
Meeting (insert link)

Frequency of Communications

It's difficult to know how frequently a prospective supplier
should contact a supplier diversity or purchasing person
to stay in touch, check in, or share new news. It can be
tricky.

I recommend that during your initial meeting
with a supplier diversity or purchasing person, ask
them how often they'd like you to connect with them.
While I can't guarantee you an answer, I can guarantee
that they do not want you to contact them on a weekly
or monthly basis, let alone to call or email them daily.

The corporate world is known to move very, *very*
slowly. Procurement projects start and stop regularly.
Some projects get placed on hold. Sourcing teams may
be redeployed to work on higher priority projects.
Sourcing people leave the company, transfer to other
departments, the budget for a project is lost, etc. I think
you get the picture. So, take your lead from the corporate
representative in terms of their personal engagement

preference and process. Here is a helpful guideline:

Category is going under review in the next six months.	Check in every two months, or as directed.
Category is under contract for three years.	Check back in two years.
Category is under contract for five years.	Check back in four years.
No immediate urgent sourcing opportunity and the category is not expected to go under review in the next twelve months.	Check in annually.

It's important to note that if a category is under long-term contract, it is still worth your time to register in a company's supplier registration portal because contracts do sometimes get canceled or expire early.

The annual check-in and touch base process can easily be managed through attendance at trade shows and conferences, or a brief email.

If a sourcing opportunity opens in your category, supplier diversity and procurement teams are trained to reach out and include small and diverse-owned

businesses for consideration. The best call is always the call from supplier diversity and purchasing teams inviting you to participate in a RFP. Be on standby and ready for when those calls come in. Then, follow their instructions and protocols to participate according to their standard operating procedures.

Supplier diversity and sourcing professionals multitask to the best of their human abilities. Like you, they must respond to competing and shifting priorities. And like you, they need work-life balance. Keep this in mind as you think about how you want to engage with people you want to turn into customers.

8

ATTENDING TRADE SHOWS AND CONFERENCES

How do I know if attending is worth it? And once there, how can I position myself to the best advantage?

You decided that you want to step up your new business development efforts and connect with supplier diversity, strategic sourcing, and corporate spend decision-makers at a supplier diversity trade show or conference.

To do this, you're going to need to do a few things to help you get a leg up on getting in front of the decision-makers that you need to connect with, form relationships, and hopefully earn a contract from.

Here are some tips and tricks to help you prepare to attend a supplier diversity trade show or conference, help you maximize your time there, and help you continue to build your network and relationships after the event.

Step 1:
Strategies to Prepare You to Attend Supplier Diversity Trade Shows and Conferences

Now that you've decided to attend a conference, you're going to have to do a few things to prepare:

1. Review the conference's website in its entirety. The website will contain critical information to help you decide to register or not.

2. Look at the agenda for each day. You'll find the conference speakers, sponsors, and in many cases, an exhibitor directory. This information will help you understand if you're truly ready to go to a conference like this, and if the companies that you want to connect with will be attending.

3. Determine what you want to gain from attending. Do you need to meet more people, is there knowledge or education you seek, do you want to check out your competition, or do you want to just see what these conferences are all about?

 Some advocacy organizations host trade show orientations to help you prepare for conference attendance and fine tune your engagement plan.

INSIDER TIP
To Go or Not to Go

Even if you are not ready to attend a big national conference, think about attending anyway. National conferences are jam packed with educational tracks, networking and speaking opportunities, and helping you to feel a part of the supplier diversity community. And quite frankly, they are a lot of work, but they are also a lot of fun.

By attending these conferences, I and other attendees constantly rave about how inspiring they can be. From my perspective they provide constant inspiration to go back to my job and fight the good fight for inclusion, work to find more opportunities, and inspire new internal champions to support the mission.

From the diverse entrepreneur perspective, I've heard them share stories about enhancing their network, securing opportunities, meeting future joint venture partners, and being uplifted by the entrepreneurial community where they can connect, learn, and grow together.

The supplier diversity organizations, along with their corporate sponsors, bring out the best speakers I've had the chance to hear in person. From celebrity entrepreneurs like Magic Johnson, Martha Stewart, and

Kim Fields to the largest minority, women, and other diverse-owned businesses in America, to pilots, race car drivers, government leaders, and more. Having the chance to access and hear from these levels of speakers could be the spark to help ignite or reignite you in ways that catapult you forward.

You also never know who you will meet at one of these events. I've not only established business relationships, but I've also established lifelong friendships among supplier diversity peers and small and diverse-owned business entrepreneurs. I met one of my friends after serving as a speaker on a panel at a regional minority business event. I've met with and mentored diverse-owned firms, and they in turn mentored me on the needs of the small and diverse business community.

You will also have to assess your return on investment (ROI) from attending the conference. Can your business afford the expense? Can you justify your time being out of the office? Can any of your conference or travel expenses be used as a tax deduction?

If conference attendance makes sense for you, register, book your hotel, airfare, and car rental to make sure you have all of the resources you need to maximize your time while there and to fully engage, knowing that you've com-

pleted all of your pre-planning activities in advance.

As a part of your social media campaign, you might want to post on LinkedIn, Facebook, or Instagram sharing announcements that you'll be attending the event. Others will then know you'll be there and may reach out to you ahead of the event to connect.

Next, develop your trade show strategy to help you achieve your goals. It can be very easy to go to a conference and just connect with people that you come across at any given time. However, that approach may not help you make the right connections you need, thereby wasting your investment from attending. Review the exhibitor directory and literally highlight and priority rank order the corporations that you want to target.

At this point, some small and diverse businesses will start an email campaign to reach out to supplier diversity professionals and buyers who plan to be at the conference to get on their schedules ahead of time. This may be a hit-or-miss approach. Some buyers like to be contacted ahead of the show to pre-set a schedule, while others may prefer just to meet during the conference. For example, if a company is going to have team members in an exhibit booth from 8 a.m. to 5 p.m. on Wednesday, I'd recommend you plan to meet them between 8 a.m. to 5 p.m. on Wednesday.

Being at a conference is like being in the middle of a whirlwind. There is a constant buzz of activity. You can literally feel the sense of excitement and opportunity. Supplier diversity leaders and buyers are doing many things. They're meeting with prospective suppliers, their own colleagues, and discussing best practices with their

peers. So as much as it is important to have a defined plan, leave room for flexibility and unplanned encounters.

From my experience, when I didn't have a staff to help manage the volume of emails and requests to meet ahead of the conference, it was very difficult to pre-schedule meetings. In those circumstances, I might post my booth hours on social media or in the conference app. Other times I may schedule time to meet with a supplier for lunch or at one of the general sessions. Meeting them outside the room and sitting together. Conferences usually feature lounges and areas to sit and hang out, which offers another chance for impromptu meetings.

When I know ahead of time the types of goods and services my company needs me to target, I'll use my time to walk the trade show floor and identify the exhibit booths of the businesses that align with my particular need. It's important for diverse entrepreneurs to remember that supplier diversity professionals and corporate buyers are looking to do business with you.

But the bottom line is that, ultimately, we're looking to do business with those companies that can provide the goods and services and solutions that our companies need at any given time. Again, don't take it personally if a buyer doesn't want to meet with you—they just may not have an opportunity for you at that time.

INSIDER TIP
Have a Trade Show Game Plan

Be sure to incorporate the time it takes to walk across the trade show floor, stand in line, and await you turn to connect. Be sure to hydrate, have lunch, take a restroom break, go outside for some personal time, and get fresh air.

Make time in your schedule to check on your progress to see if you're accomplishing the goals that you laid out for yourself. You may have to make some hard calls to skip over a presentation or not meet with someone if it doesn't align with your trade show game plan and strategic approach.

Most importantly wear comfortable shoes. You can thank me for that later.

Step 2:
Attend Supplier Diversity Trade Shows and Conferences

Now that you've generated your tradeshow approach, it's time to execute. Make sure you know the trade show hours and begin engaging at the start of the conference time. Hit the ground running from the very beginning.

During events when I meet with a prospective supplier, I'm looking to learn a few things from you to help me understand what next step to take, if any. I've been in the supplier diversity space for a long time, and I've had the privilege to meet with and interview a wide range of businesses—from those who sell plastic injection molding components, cold roll steel, and fasteners, to those who offer actuarial services, learning solutions, and video production. I'm skilled at interviewing and processing firms quickly to determine if, how, and where your services align with my company's operation.

Below are key data points I like to discover during a first encounter. If you don't take the lead in our meeting to share these details, which is preferred, I generally ask the following questions in this order:

1. What is your name? Your company name?

2. What products/services do you provide? What division(s) within my company do you generally call on?

3. What is your company's unique value proposition?

4. What customers do you have that are of a similar size to my company?

5. Do you or have you done work in my industry? With my competitors?

6. How many years have you been in business?

7. What is your company's total annual revenue? (If you can share it.)

8. How many employees do you have?

9. What is your geographic footprint (e.g., local, regional, national, or global)?

10. Do you have the necessary industry certifications, diversity certifications, licensing, or bonding required for your industry?

11. Do you have any case studies to demonstrate how you've provided solutions and measurable results to other corporations with the same size and geographic footprint as my company?

12. What questions do you have for me?

13. Is there anything else you'd like me to know about your firm?

This sequence of questions allows me to quickly learn—from questions one through five—whether you fit within my company. As you're speaking to me, in my mind I'm visualizing our business units, our supply chain organizational chart, and other internal leaders who may benefit from meeting you. I also believe this sequence of questions allows you to unpeel the layers of your business, like an onion, to share layers of information.

If more time allows at the end of this series of questions, I also love and am fascinated by hearing how your

business came into being, why you decided to become an entrepreneur, what led you to be here today, and what impact you want to make on society with your business. If it's unique, what is the story behind the name of your business? I look for other notable information that makes your firm memorable to me and to others.

I'm also personally inspired and proud of the entrepreneurs I meet, and I respect what you've built. Being able to hear your origin story is a gift and continues to make me excited and passionate to be a supplier diversity leader who is instrumental in helping my company and small and diverse-owned businesses connect and achieve their mutual goals.

INSIDER TIP
We're Open. We're Closed.

Keep in mind that each conference has designated show hours. Corporate representatives are scheduled to be in their exhibit booths from 8 a.m. to 5 p.m. or whatever the designated hours may be. At the start of the day corporate attendees are excited, and we want to engage with you quickly. Oftentimes our booths are staffed more heavily during the morning hours to maximize engagement time with conference attendees.

Think about human nature—at the start of the day people are fresh, they're energetic, they're ready to go. As the day winds down, people can start to get tired.

In my experience, company representatives want to hit the ground running right as a trade show or conference opens. We want to see you moving in and connecting with us early and quickly.

By 4 p.m., most people working the exhibit booths are beginning to get tired, and in many cases lose their voice. There have been many times where I'm talking to people non-stop from 8 a.m. and throughout lunch. I generally start to lose my voice around 2 p.m.

So, you may want to keep in mind that at about 4 p.m., or one hour before closing, many corporate representatives are thinking about closing up shop. It may not be fair because they have a full hour left to engage, but people do get tired, may need to catch evening flights home, or may have post-conference team meetings, dinners, or other post-conference activities to prepare for. So, I recommend getting in and making your connections as early in the day as possible.

One of my personal pet peeves is when prospective suppliers visit our booth at the very end of the exhibit time frame. The trade show hours are posted as beginning at 8 a.m. and closing at 5 p.m. But oftentimes, there will be a business owner or two approaching the exhibit booth at five minutes to 5 p.m. Personally, I think that's inconsiderate and a bad business approach.
Don't be that person.

Step 3:
Post-Trade Show or Conference Engagement

After the event, it's your responsibility to review and process all leads you generated over the course of conversations you had during the tradeshow or conference experience. We are also processing the leads we generated and assessing and acting on the appropriate next steps. Outline and prioritize those companies that you want to follow up with based on the specific instructions or preferred communication protocol they gave you.

In general, be thoughtful. Remember that once the conference has concluded, those corporate representatives, like yourself, have been out of their office for at least a week. That means they're behind on catching up on emails, responding to the needs of their boss or other corporate team members, and they're also behind on family and personal time. It's not recommended to contact them the day after the conference or even a week or so after the conference, unless they specifically asked you to. They need to go through emails and get caught up themselves before re-engaging, as well as processing the leads they generated, and prioritizing their own next steps.

If a company met with you for ten to fifteen minutes or more at a trade show or conference, then it is very likely that they've asked you the relevant questions they needed to know. They know how, when, and where you could fit within their company's supply chain. If they need more information, they know how to get in touch with you. I wouldn't recommend calling on that prospective custom-

er again in the short-term unless they've specifically asked you to do so. The reality of working for a large corporation is that we have so many prospective suppliers contacting us daily that it can be difficult to manage ongoing conversations with suppliers that don't meet the present needs of our business. In this circumstance, it really is in your best interest to stand by until you learn about a relevant opportunity.

However, for those companies that gave you specific instructions to call them at a designated time, make sure that you follow through immediately, and as instructed. Put a reminder on your calendar to contact them on a certain day. If they asked, send them follow-up information, whether it was a PowerPoint presentation, a link to your website, or any other additional information. Follow through on those specific tasks first because if they asked you for that information at a certain time frame, that means they've already thought about how they could move you further into the engagement process with other leaders at their company.

9

STRATEGIC NETWORKING

What are some other ways to get myself in front of the supplier diversity professionals of companies I've targeted?

Never miss a chance to network. It is something you can do in almost any situation—whether your budget allows you to attend a conference or trade show or not. Even if you do attend an event and your attempts to connect with supplier diversity professionals didn't materialize, you can reconnect with them in other ways to continue to build relationships and remain top of mind. Consider these other networking ideas:

Networking Breakfast, Lunch, or Dinner

Some small and diverse-owned businesses have breakfast, lunch, or dinner meetings to carve out time for focused conversations with corporate representatives. If their time allows, this is a great way to connect. We all need to eat at some point, right? It's also important to note that you shouldn't have to always foot these bills. I often pay my own way as I don't want to take advantage of a free meal, and I often don't want the supplier to misinterpret that

just because we broke bread I can get you a contract.

In addition, for some corporations and certainly in the government space, supplier diversity and purchasing team members may not be allowed to accept a meal as it may be considered a bribe or against company policy. So, understand if the offer to pay for a meal or have a meal is not accepted.

Advisory Boards

An innovative approach that some entrepreneurs use is the establishment of an advisory board that is made up of experienced leaders across various disciplines—such as supplier diversity, purchasing, marketing, human resources, finance, or other disciplines—to periodically meet with them. The goal of these meetings is to provide a summary of their business accomplishments and challenges and get input and feedback on their growth and progress. These meetings can help the advisory board make recommendations on resources inside or outside of their network that could benefit the business.

Peer Networking

Another approach is to establish regular meetings to network with other entrepreneurs within and outside of your industry to share success stories, horror stories and gain insight and perspectives from those who are walking a similar path as you.

INSIDER TIP
Networking Out of the Box

One of my supplier diversity peers recently secured a new job from the relationship he built while serving on a community board of directors. His new CEO served on the same board. Based on their relationship, my peer was able to encourage the CEO to start a supplier diversity program with him as the lead.

A woman-owned business I know used this approach and she ended up being the only entrepreneur in the room which gave her access to several CEOs in her community—some of whom she was able to do business with.

Imagine how as a small or diverse-owned business entrepreneur you could gain added value through volunteering or civic participation that also helps you network, build relationships, and possibly secure new business for your company.

10

ONBOARDING INTO THE CORPORATE SUPPLY CHAIN

What process should I expect once a company shows interest in my business?

On our side of the equation, those of us who work with diverse entrepreneurs think about our relationship with you along this continuum:

» Pre-engagement

» Post-engagement

» On-going engagement

Entrance for a small or diverse-owned business into a corporate supply chain often begins with the company's office of supplier diversity and their supplier diversity team. The diverse supplier onboarding process is a series of steps to turn you from a prospective diverse supplier to a diverse supplier to a strategic diverse supplier partner. Here I'll show you a typical approach for how some small and diverse-owned businesses get added into a corporate supply chain. Depending upon the criticality of your goods

or service to the business and the priority-level of our sourcing needs, this process could move very, *very quickly* or very, *very slowly*.

As described in detail in chapter six, by this point you will have already registered your business into the corporation's supplier diversity portal, thus ensuring that if employees leave the company or get promoted to another area of the business, your firm will remain visible to the sourcing leaders. Then, as chapter seven detailed, you have introduced yourself to the supplier diversity team, providing them with a brief high-level overview of your company's capabilities, core products and services, customers, experience, etc. Maintain a relationship with this team or person over time.

Phase 1 - Under Review

The supplier diversity team will route your information to the appropriate internal sourcing team, commodity managers, and/or business unit leaders based on the priority-level of the products and services you sell at that point in time. Your information will be reviewed based on these factors: the company's sourcing needs, the criticality of your goods and service to their business operations, their perceived priority level for what you sell, and if a contract is in place.

Active Need, Mission Critical to the Business: Fast-Track. For example, during the COVID-19 pandemic, suppliers who provided cleaning products and PPE were immediately fast-tracked to sourcing teams and business leaders. These supplies were deemed mis-

sion critical and essential to business operations, and the health, safety, and welfare of employees and customers.

Sourcing and supplier diversity teams are actively looking for suppliers that address a mission critical business need. Supplier calls and email responses will be fast- tracked, sometimes based on the order they come in. If your goods and services are not deemed mission critical, your company may fall to no-track. Be ready to engage and respond if your company is called.

Active Need, RFP Approved for Current Year: Medium-Track. When a RFP is planned to be issued for the company's current year, the project will take place when the project teams are deployed and ready to begin work. These projects may move forward as planned, be placed on hold, or canceled, based on the shifting priorities and needs of the company.

Sourcing and supplier diversity teams are actively looking for suppliers to participate in a RFP occurring in the short-term. Supplier calls and email responses will be fast- or medium-track depending on where they are in the RFP project process: not yet started, initiating, implementing. Be ready to engage and respond if your company is called.

Possible Need, No RFP Planned: Slow-Track. Sourcing and commodity managers may conduct supply chain reconnaissance to research the landscape of diverse businesses for future possible purchases. They may do this when they are new to their category, want to understand the availability of small and diverse-owned businesses in their commodity space, are considering conducting a RFP, or want to build out their pipeline of suppliers for back-ups and emergencies. These engagements move forward based on the sourcing manager's availability.

Don't be surprised or concerned if company representatives are slow to respond to your emails or phone calls. This may mean the company is pursuing other categories that have a higher opportunity for diverse supplier inclusion and are deploying their human capital in alignment with business needs. This presents you with the opportunity to reconnect and stay in touch at other events.

No Need, Contracts in Place, Long-term Expiration Date: No-Track. If a contract is in place for another three to five years, the supplier is meeting/exceeding goals, a new RFP is not expected to go to bid in the short-term, there is no need to actively engage. This is the slowest track, as your category represents a lower-level sense of urgency and need to the business as they have a suitable solution in place.

Don't be discouraged if company representatives are unwilling to meet with you at this time. They are likely pursuing other categories that have a higher opportunity for diverse supplier inclusion and are deploying their human capital to meet those business needs. Again, think of this as a great time to reconnect and stay in touch at other events.

Phase 2 - Meet the Sourcing or Commodity Manager

After the internal review process has occurred, the aligned sourcing manager will schedule a capability meeting with companies they believe are congruent with the needs of their business. Meetings may be meet and greets for introductions and awareness, or to understand capabilities in preparation for an upcoming RFP or bid solicitation.

Phase 3 - Meet the Department or Business Unit Decision Maker(s)

Once the sourcing manager has selected company's they would like to continue to progress through the supplier engagement and onboarding process, they will then introduce prospective suppliers to department or business unit leader(s) who make the purchasing decisions in that segment of the company. A capability meeting will be scheduled to continue the discovery dialogue and the relationship-building process.

Phase 4 - Participate in the Request for Information, Request for Proposal, and Request for Quotation Process

After supply chain management leadership and the department or business unit leader agree that a RFP project will be initiated, the sourcing team develops and initiates a formal RFP project. Suppliers who have met the criteria to participate based on your demonstrated ability to provide the necessary goods and services, will be invited to participate in the RFP. RFPs can be quick turnaround projects of two months, or they could take a year or more depending on the category, complexity of the product or service, or alignment to critical areas of business operations.

Phase 5 - Supplier Selection

Congratulations, you have just been awarded a contract! Nice job! After your team and families have celebrated, and after you've thanked your staff for delivering a win, it's time to complete the formal supplier onboarding process. If your company did not win the contract award, request a debrief from the company as to why your company was not successful. The lessons learned could help you compete for and win this project in the future, or to better prepare you to compete and win at another company.

Phase 6 - Onboarding Begins

This process may look different at each company but typically you'll be asked to:

1. **Create a Vendor Profile.** This could include your company name, address, contact information, tax ID, payment details, products/services you will provide, business and diversity business classifications, diversity certifications, etc.

2. **Understand Customer Expectations.** For example, familiarize yourself with your customer's supplier code of conduct, supplier scorecard, social responsibility, sustainability, diversity, equity, and inclusion and supplier diversity plans. You may have been briefed on these elements during the RFP process, or even asked to share similar plans for your company. The point is that it is important for you to be clear on the company's expectations of its supply base. If not, these discussions may take place at this point.

 Once you become a supplier to a company it is your job and your responsibility to sustain and maintain your contract and deliver the necessary products and services to ensure contract renewals over the years. Your aim is to never give a corporation a reason to replace you for just or unjust causes. Expand your network and relationships into other divisions that may allow you to grow your business and expand the services you provide to your customer. Your goal is to become a strategic supplier partner, one that is indispensable.

Phase 7 - Achieve Strategic Supplier Partner Status

After you've been able to demonstrate that you are a reliable strategic supplier, you'll attain strategic supplier

partner status. Continue to build your relationships within the company to obtain more business. The company will feel more comfortable endorsing you and referring you to other corporations. They may even recommend you to receive supplier of the year award recognition by their company or by one of the supplier diversity advocacy organizations.

11
PUTTING IT ALL TOGETHER

Is there anything else I need to know?

By the time you've gotten to this chapter, my hope is that you have a better understanding of what happens within corporate supplier diversity and supply chain teams, and their efforts to build an inclusive supply base that represents the people within the communities in which they operate.

Large corporations and their supplier diversity and procurement buyers are intentionally seeking to do business with small, minority, women, Veteran, LGBTQ+, and disability-owned firms as well as other historically underutilized diverse categories. Your key to success in this story is to be open-minded, respectfully patient, and prudently persistent. I encourage you to use the lessons learned in this book to give you a leg up on how to navigate the supplier diversity space.

I also want to encourage you to establish your own supplier diversity policy and program similar to what corporate suppliers have in place. Just like large corporations are holding themselves socially responsible to engage,

connect, and do business with entrepreneurs like you, I encourage you to do the same. You may be surprised to learn how other entrepreneurs can positively impact you personally as well as your business beyond the sales you may generate from them.

Go out and knock on the doors of companies that you truly believe you can provide with quality products, goods, and services, and offer them tangible solutions to their supply chain needs. Continue to build your networks and relationships and follow the instructions of those companies which have described on their public websites how to best market yourself to and connect with them.

Be persistently patient. The procurement cycle revolves, so it may be a matter of months or years before a company is looking to buy your goods and services again. Continue to believe in yourself and the business you have built. Chase after your dreams and take it from me—you will be able to get into one, or even many more, of the corporate supply chains that you desire. And that is just the beginning!

APPENDIX

As mentioned in chapter three, this section covers information about the organizations that certify diverse-owned businesses, information on the certification process, and the benefits of these certifications from the perspective of diverse business entrepreneurs and buying organizations. Use this information to determine which certifications you want to apply for and the steps to secure one.

Minority-Owned and Small Disadvantaged Business

The National Minority Supplier Development Council (NMSDC)

The NMSDC is the leading certifier for minority-owned businesses in the US and is widely recognized in corporate America. The NMSDC also has several international affiliates, including Australia, Canada, China, South Africa, and the United Kingdom.

The NMSDCs certification application process https://nmsdc.org/mbes/mbe-certification/ is managed and conducted by regional councils online here: https://nmsdc.org/our-network/. Once you've located the council nearest you, contact them for assistance.

If you are seeking to secure designation as a small disadvantaged business (SDB) visit the U.S. Small Business Administration website for instructions on how to self-represent your firm: https://www.sba.gov/

federal-contracting/contracting-assistance-programs/
small-disadvantaged-business.

The NMSDC is the blueprint for the other supplier diversity advocacy certifying organizations that came after them and has been in existence for more than fifty years.

I have been a corporate member representative of this organization my entire career in supplier diversity and have regularly attended their conferences. NMSDC hosts a wide range of programs designed to help minority-owned businesses develop and grow and remain abreast of industry trends that their corporations belong to across eighteen industry groups. I served as their chair for the Air, Rail, and Transportation Industry Group for several years. And as I write this book, I am a member of the Financial Services Roundtable for Supplier Diversity (FSRSD).

These industry sectors make it easier for prospective suppliers to identify and target companies with supplier diversity programs who are looking to connect with them. Each industry group offers their own additional educational sessions and networking events to connect and help your business grow.

NMSDC also has a National Minority Business Enterprise Input Committee (NMBEIC), https://www. nmbeic.org/, that represents the interest of minority-owned businesses and aligns across industry segments.

NMSDC has an awards and recognition program to highlight the National Corporation of the Year, the National Supplier of the Year, and more to recognize advocacy and excellence within the supplier diversity space.

Woman-Owned

The Women's Business Enterprise National Council (WBENC)

WBENC is the leading third-party certifier for women-owned businesses and is widely accepted in corporate America. The certification application process is conducted online here: https://wbenc.wbenclink.org/. Go to WBENCs list of regional partner organizations: https://www.wbenc.org/regional-partner-organizations/. Once you've located the council nearest you, contact them for additional assistance.

Like NMSDC, WBENC offers a plethora of programs and services designed to educate and grow the capacity of women entrepreneurs. I've had the pleasure to serve on committees, like the Global Committee, and work alongside my peers and women entrepreneurs to advocate for, support, and advance the interests of women businesses around the world.

WBENC also offers robust networking, features a Top Corporations Award, All Stars Award for Women Businesses, and stellar speakers at their conferences.

WEConnect International

WEConnect International is a partner to WBENC, the leading certifier for women-owned businesses around the world and is widely accepted in corporate America. The certification application process is conducted online at: https://www.weconnectinternational.org/en/womens-business-enterprises/certification.

WEConnect offers a range of programs and services, as well as an extensive global affiliate network and resources to support women entrepreneurs across many global markets. They feature a wealth of resources to understand the economies in the regions they serve, and grant awards for top global champions for supplier diversity and inclusion, and awards for leading global women entrepreneurs. I previously served on their Corporate Member and Best Practices Committees.

Veteran-Owned and Service-Disabled Veteran-Owned

National Veteran Business Development Council (NVBDC)

NVBDC is a certifier for Veteran and service-disabled Veteran-owned businesses and is widely accepted in corporate America. The certification application process is conducted online here: https://nvbdc.org/certification-landing-page/

National Veteran-Owned Business Association (NaVOBA)

NaVOBA is a certifier for Veteran and service-disabled Veteran-owned businesses and is widely accepted in corporate America. The certification application process is conducted online here: https://www.navoba.org/certification.

To qualify as a service-disabled Veteran-owned small business, go to the Small Business Administration (SBA) website: https://www.sba.gov/federal-contracting/

contracting-assistance-programs/service-disabled-veteran-owned-small-businesses-program.

Lesbian, Gay, Bisexual, and/or Transgender-Owned

National LGBT Chamber of Commerce (NGLCC)
The NGLCC is the certifier for lesbian, gay, bisexual, and/or transgender-owned businesses and is widely accepted in corporate America. The certification application process is conducted online here: http://www.nglcc.org/get-certified.

As with each of the advocacy organizations, NGLCC also offers many programs and services, and mentor protégé opportunities to advance LGBTQ+ entrepreneurs. They have global affiliates around the world advocating for and supporting LGBTQ+ businesses.

As I write this book, I currently serve on NGLCC's Corporate Advisory and Procurement Councils.

Disability-Owned

Disability:IN
Disability:IN is the certifier for disability, service-disabled Veteran, and Veteran disability-owned businesses and is widely accepted in corporate America. The certification application process is conducted online here: https://disabilityin.org/what-we-do/supplier-diversity/get-certified/.

Disability:IN offers programs and services, and mentor protégé opportunities. As I write this book, I currently serve on Disbility:IN's Procurement Council.

Federal Government Diversity Classifications

The United States government has additional diversity classifications you should be familiar with if you intend to do business with the federal government.

HUBZone

HUBZones are businesses located in historically underutilized business zones. To learn about requirements and to apply to become certified as a HUBZone Business, contact the Small Business Administration (SBA). https://www.sba.gov/federal-contracting/contracting-assistance-programs/hubzone-program.

Small Business

The federal government uses several criteria to determine if your firm is eligible to be classified as a small business including NAICS code, number of employees, and revenue. To learn if your firm qualifies, follow the steps below:

Visit sba.gov. https://www.sba.gov/federal-contracting/contracting-guide/size-standards. Review the section titled "size standards."

At the size standards tool, follow the instructions to check your status. You will need to know the NAICS codes, https://www.census.gov/naics/, associated with your business to complete the process.

After completing the online form, the size standards tool will analyze your status and provide a response. If classified as a small business, share your status with your customers and prospective customers.

Certification Process

Based on the diversity certifications you choose to pursue, the application process will be similar across all advocacy organizations. Key criteria and steps you can expect to take are outlined below.

» Business must be at least 51 percent owned, operated, and controlled by the diverse individual(s).

» Complete and return an application to the certifying agency you choose. Applications can be submitted throughout the year.

» The average processing fee can range from an estimated $200 or more depending on the certifying organization. Most can be initiated online. Applicants are required to submit financial and legal documentation to support the information submitted in the application.

» An in-person or virtual site visit will be conducted during normal business hours and may also include home-based and leased facilities.

» The process can take forty-five to ninety days or more.

» An annual or bi-annual renewal acknowledging that no new ownership, management, or control changes have taken place during the year must be submitted.

If you need assistance completing your application, contact the certifying organization for assistance. Also, consider leveraging your lawyer, or hiring a supplier diversity consultant or other firm to assist you through this process.

Benefits of Certification to Diverse Entrepreneurs

Minority, women, LGBTQ+, disability, and Veteran-owned business certification programs are designed to assist the growth and development of businesses owned and controlled by individuals who identify as belonging to these categories. An important goal of supplier diversity programs is to increase the participation of these businesses in the procurement activities of the federal government, corporations, and other buying institutions.

Certification affords diverse-owned business enterprises the opportunity to:

» Gain access to new markets and increase revenue.

» Be listed in national and/or regional directories of certified diverse-owned business enterprises used by corporate America, federal, state, and local agencies, and other institutions in their procurement process.

» Attend national and/or regional diversity trade shows where large corporations, government agencies, and other buying entities are specifically seeking to network with and do business with certified diverse businesses.

» Gain a competitive advantage when marketing to the federal government. The government and their subcontractors have been mandated by law to provide greater opportunity for small and federally classified diverse firms to provide goods and services to them.

» Network with other certified diverse business enterprises, which may lead to professional development, joint ventures and/or strategic alliances, as well as additional sales opportunities.

Certification for diverse business enterprises is a unique value proposition, a competitive differentiator, a customer service solution, and a ticket to access.

Benefits of Certification to Buying Organizations

The federal government requires its suppliers, by law, to track and report their utilization of federally classified diverse suppliers. In addition, large corporations require their suppliers, by contract and by verbal request, to track and report their spend and engagement with certified diverse business enterprises.

Certification of diverse-owned businesses affords buying organizations the opportunity to:

» Report performance with certified diverse business enterprises to federal and corporate clients.

» Comply with federal and corporate contracts.

» Maintain and expand business with customers who value the inclusion of certified diverse business enterprises in its supply chain.

» Support a company's ability to satisfy the demands of their clients, which may lead to more business.

» Demonstrate a shared commitment to doing business with certified diverse business enterprises.

» Support a company's access to emerging markets (e.g., certified diverse business enterprises as customers).

The top value proposition for diversity certification to buying organizations is the comfort and assurance that they are, in fact, doing business with a diverse-owned business enterprise. Assuring that the firm is not a "front" and the accuracy and integrity of their diverse supply base and the spend they incur with diverse-owned suppliers is sound.

What to Expect After You Obtain Your Diversity Certification

First things first, a diversity certification is not a guarantee that you will instantly earn a multi-million-dollar contract and become a business mogul and an overnight sensation. Just like a lottery ticket, it could happen, but more than likely your business will continue to go through the normal paces of becoming more successful and more profitable overtime. When you earn your diversity certification, I recommend you:

1. Attend any newly certified training or orientation sessions being offered by your certifying advocacy organization. Just like when you join a new gym or move into a new apartment complex, it's important to get the lay of the land. Get to know the staff and their roles, learn about their programs and services.

2. Highlight services you're most interested in then priority rank them. Just like with any new project, create a plan for how you intend to leverage this new marketing tool.

3. Consider meeting with some of the other newly minted certified firms you met during orientation. Think about setting up periodic meetings or check-ins to ensure you're making use of your certification and your new access to other entrepreneurs and corporate supplier diversity leaders.

4. Discuss lessons learned.

5. Attend one of the advocacy organization events in your local market to expand your network and really learn how the certification can best work for you.

The certification also grants you access to a database of their corporate members, and in some cases to your peer certified entrepreneurs, allowing you to target your new business development efforts to not only large corporations but other small and diverse-owned businesses who could also use your goods and services.

Always be mindful that the business you built is the shining star, the lead character. The certification is—the icing on the cake, a supporting role, another added value, and a competitive differentiator that helps you tell and sell your story.

GLOSSARY

Below is a listing of common terms and definitions used within the supplier diversity space, which may be found in the public domain.

Affirmative Action: Strategic policies and procedures required of federal contractors that are designed to achieve equal employment opportunity. Affirmative action obligations represent a contractual commitment and entail the establishment of systematic efforts to prevent discrimination from occurring or to detect it and eliminate it under all federal contracts.

Audit: Conducted periodically by the Office of Federal Contract Compliance Programs (OFCCP), this oversight practice seeks to confirm compliance with Federal EEO regulations on the part of federal contractors. The audit may consist of a "desk audit" or an on-site visit. Key determinants in this evaluation include documentation of efforts of good faith in line with objectives in the company's approved affirmative action plan.

BDR (Billion Dollar Roundtable): The BDR represents an elite group of leading corporations that practice supplier diversity as a core element of their supply management strategy. It was created in 2001 to recognize and celebrate corporate achievement in support of minority and women suppliers represented by each BDR member achieving

$1 billion in total Tier 1 spend with these groups. The BDR promotes and shares best practices in supplier diversity excellence, setting the standard nationally for performance.

Certification: Certification validates the ownership of a diverse business to ensure against inaccurate reporting of spend data. Third-party organizations such as National Minority Supplier Development Council (NMSDC) which certifies minority-owned businesses and Women's Business Enterprise National Council (WBENC) are the accepted sources of diverse supplier certification.

Compliance: Meeting the full requirements and contractual obligations imposed by regulatory directives of government as well as the terms and conditions of each contract.

Disabled: A small business concern that is at least 51 percent owned by one or more individuals whose physical or mental abilities prevent them from fully participating in normal activities and/or functions of living (the intended beneficiaries of The Americans with Disabilities Act (ADA)), or, in the case of any publicly owned business, at least 51 percent owned by one or more disabled individuals and whose management and daily business is controlled by one or more such individuals.

FAR (Federal Acquisition Regulations): U.S. government guidelines that outline uniform policies and procedures

for acquisition of all goods and services by federal agencies and federal contractors. Key sections of the FAR include Part 19 and Part 52 covering small business requirements.

Goals: Goals represent desired performance objectives (targets) that are used as guidance in formulating a results-driven supply chain strategy. They ensure continued progress toward improvement in all components of the supply chain strategy, including cost reduction, service improvement, innovation, and supplier diversity performance.

HBCU (Historically Black Colleges and Universities): These are educational institutions determined by the secretary of education to meet the requirements of 34 CFR 608.2. HBCUs are non-profit research institutions playing an integral part in technical research and innovation along with other leading institutions.

Lesbian, Gay, Bisexual, Transgender (LGBT)-owned: A business concern which is at least 51 percent owned, operated, managed, and controlled by an LGBT person or persons who are US citizens and exercise independence from any non-LGBT business enterprise, have its principal place of business (headquarters) in the United States, and have been formed as a legal entity in the US.

Limited Competition: A process outlined in the FAR calling for reducing the competitive supply pool for identified procurements limited to underutilized groups that

are ready and available in the marketplace. The process ensures competitive access and full participation without the need for compromising performance expectations.

Mentor-Protégé Program: A supplier development strategy designed to increase capabilities, capacity, and growth opportunities for small, women, minority and Veteran-owned firms. The program encourages collaborative relationships between subcontractors and prime contractors to identify and address the developmental needs of small businesses.

Minority Business: A for-profit business enterprise, regardless of size that is owned, operated and controlled by an American citizen who is a member of a minority group. The minority ownership must constitute at least 51 percent of the business enterprise with full responsibility for management and control of daily operations.

Minority Groups

Asian-Indian: A US citizen whose origins are from India, Pakistan, and Bangladesh.

Asian-Pacific: A US citizen whose origins are from Japan, China, Indonesia, Malaysia, Taiwan, Korea, Vietnam, Laos, Cambodia, the Philippines, Thailand, Samoa, Guam, the U.S. Trust Territories of the Pacific, or the Northern Marianas.

Black: A US citizen having origins in any of the Black racial groups of Africa.

Hispanic: A US citizen of true-born Hispanic heritage, from any of the Spanish-speaking areas of the following regions: Mexico, Central America, South America, and the Caribbean Basin only. Brazilians shall be listed under Hispanic designation for review and certification purposes.

Native American: A person who is an American Indian, Eskimo, Aleut, or Native Hawaiian, and regarded as such by the community of which the person claims to be a part. Native Americans must be documented members of a North American tribe, band, or otherwise organized group of native people who are indigenous to the continental United States, and proof can be provided through a Native American Blood Degree Certificate (e.g., tribal registry letter, tribal roll register number).

NAICS (North American Industry Classification System): NAICS codes are the standard identifier used by all industries and the federal government to classify industrial, commodity, and service product categories.

SAM (System for Award Management): This is the official U.S. government small business database system that consolidates the capabilities of CCR (Central Contractor Registration) federal regulations, ORCA (Online Representations and Certifications Application), and EPLS (Excluded

Parties List System). There is no fee to register for this site.

Supplier Development: Supplier development is an essential element of the procurement strategy for developing a world-class integrated supply chain. The process must offer numerous resources for suppliers to support their continuous improvement and growth.

Supplier Diversity: A tactical and strategic business practice that focuses on creating competitive access for diverse small businesses as suppliers and contractors.

Supply Management: Innovative measures that outline various strategies for managing the products and/or resources needed to run a business from raw materials to unique services.

Tier 1 Supplier: A supplier who is awarded a contract directly from a customer.

Tier 2 Supplier: A subcontractor; a supplier awarded a contract by a Tier 1 prime supplier.

Underutilization: Low participation and representation of minority and women-owned firms in commodity categories or services substantially below their levels of availability in the marketplace.

Women-owned Enterprise: A small business concern which is at least 51 percent owned by one or more women,

or, in the case of any publicly owned business, at least 51 percent of the stock of which is owned by one or more women and whose management and daily business operations are controlled by one or more women.

8(a): The U.S. SBA's 8(a) Business Development Program, named for a section of the Small Business Act, and created to help small, disadvantaged businesses compete in the American economy through access to the federal procurement marketplace.

HUBZone: HUBZone firms are small businesses located in economically distressed areas as identified by the U.S. SBA.

Small Business: A business, including its affiliates, that is independently owned and operated, not dominant in its field of operation, and meets U.S. SBA size standards by revenues and industry. Please refer to the small business area on the SBA site for additional information.

Small Disadvantaged Business: Federal terminology describing a small business concern that is at least 51 percent owned by socially and economically disadvantaged individuals, or, owned business, and whose management and daily business is controlled by one or more such individuals. Please refer to the small, disadvantaged business area on the SBA site for additional information.

Veteran-owned: A small business concern that is at least

51 percent owned by one or more Veterans, or, in the case of any publicly owned business, at least 51 percent of the stock of which is owned by one or more Veterans and the management and daily business operations of which are controlled by one or more Veterans.

Service-disabled Veteran: A small business concern that is at least 51 percent owned by one or more service-disabled Veterans (a Veteran with a disability that is service-connected), or, in the case of any publicly owned business, at least 51 percent of the stock of which is owned by one or more service-disabled Veterans and the management and daily business operations of which are controlled by one or more service-disabled Veterans, or, in the case of a Veteran with permanent and severe disability, the spouse or permanent caregiver of such Veteran.

ENDNOTES

1. David Wessel, "The U.S. in 2050 Will Be Very Different Than It Is Today," Peter G. Peterson Foundation, https://www.pgpf. org/us-2050/research-summary#:~:text=America%20will%20 also%20be%20more,will%20have%20more%20than%20doubled

2. Jeffrey S. Passel and D'Vera Cohn, "U.S. Population Projections: 2005-2050," Pew Research Center, Washington, D.C., February 22, 2008, https://www.pewresearch.org/hispanic/2008/02/11/us-population-projections-2005-2050/

3. Jonathan Vespa, Lauren Medina, and David M. Armstrong, "Demographic Turning Points for the United States: Population Projections for 2020 to 2060," February 2020, https://www. census.gov/content/dam/Census/library/publications/2020/ demo/p25-1144.pdf

4. Abby Budiman and Neil G. Ruiz, "Key Facts About Asian Americans, a Diverse and Growing Population," Pew Research Center, Washington, D.C., April 29, 2021, https://www. pewresearch.org/short-reads/2021/04/29/key-facts-about-asian-americans/#:~:text=The%20nation%27s%20Asian%20 population%20rose,four%20times%20their%20current%20total

5. Merritt Melancon, "America's Economy Continued to Grow and Diversify While Recovering from COVID-19," Terry College of Business, University of Georgia, June 6, 2023, https://www.terry. uga.edu/americas-economy-continued-grow-and-diversify-while-recovering-covid-19/

6. The U.S. Census Bureau, Press Release Number CB23-112, October 26, 2023, https://www.census.gov/newsroom/press-releases/2023/annual-business-survey-employer-business-characteristics.html

7. Melanie Hanson, "College Enrollment & Student Demographic Statistics," Education Data Initiative, January 10, 2024, https://educationdata.org/college-enrollment-statistics

8. Wendy Wang and Kim Parker, "IV. By the Numbers: Gender, Race and Education," Pew Research Center, Washington, D.C., August 17, 2011, https://www.pewresearch.org/social-trends/2011/08/17/iv-by-the-numbers-gender-race-and-education/

9. U.S. Federal Acquisition Regulations, "52.219-9 Small Business Subcontracting Plan," May 22, 2024, https://www.acquisition.gov/far/52.219-9

10. Matthew Pavelek, "The Value of Vetrepreneurs: The Business Case for Including Veteran's Business Enterprises in Supplier Diversity," The National Veteran-Owned Business Association (NaVOBA), January 1, 2023.

11. Michelle Yin, Dahlia Shaewitz, Cynthia Overton, and Deeza-Mae Smith, "A Hidden Market: The Purchasing Power of Working-Age Adults with Disabilities," American Institutes for Research, April 17, 2018, https://www.air.org/resource/report/hidden-market-purchasing-power-working-age-adults-disabilities

12. National Gay and Lesbian Chamber of Commerce, "America's LGBT Economy 2016 Snapshot," Washington, D.C., 2016, https://nglcc.org/wp-content/uploads/2022/02/REPORT-NGLCC-Americas-LGBT-Economy-1-1.pdf

13. Rebecca Betterton, "The Rising Purchasing Power of Women: Facts and Statistics," Bankrate, January 4, 2023, https://www.bankrate.com/loans/personal-loans/purchasing-power-of-women-statistics/

14. Michael Chui, Brian Gregg, Sajal Kohli, and Shelley Stewart III. "The Black Consumer: A $300 Billion Opportunity: Serving the Emerging Black American Consumer," McKinsey & Company," August 6, 2021, www.mckinsey.com, https://www.mckinsey.com/featured-insights/diversity-and-inclusion/a-300-billion-dollar-opportunity-serving-the-emerging-black-american-consumer

15. J. Merritt Melancon, "The Multicultural Economy 2021," Terry College of Business, University of Georgia, August 11, 2021, https://news.uga.edu/selig-multicultural-economy-report-2021/

16. Ana Paula Calvo, Carolina Mazuera, Jordan Morris, Bernardo Sichel, and Lucy Perez, "The Economic State of Latinos in the US: Determined to Thrive," McKinsey & Company, November 14, 2022, https://www.mckinsey.com/featured-insights/diversity-and-inclusion/the-economic-state-of-latinos-in-the-us-determined-to-thrive

17. Leanne Strickler, "Understanding the Famous 7-Step Strategic Sourcing Process," August 5, 2021, https://www.suppliergateway.com/2021/08/05/understanding-the-famous-7-step-strategic-sourcing-process/

18. The Purchasing Procurement Center, "The 7 Step Strategic Sourcing Process!" https://www.purchasing-procurement-center.com/strategic-sourcing-process.html

19. Simfoni, "Introduction to Sourcing," https://simfoni.com/sourcing/

20. Text generated by ChatGPT, OpenAI, April 13, 2023, in response to "Explain the difference between a supplier diversity professional and a strategic sourcing manager." Edited for content and clarity.

21. U.S. Government Accountability Office, "COVID-19 Pandemic: Observations on the Ongoing Recovery of the Aviation Industry," GAO-22-104429, October 21, 2021, https://www.gao.gov/products/gao-22-104429

22. Pandadoc blog, "How to Write a Business Case Study: Your Complete Guide," March 30, 2023, https://www.pandadoc.com/blog/how-to-write-a-business-case-study/#:~:text=A%20good%20case%20study%20should,Credible%20client%20testimonials

23. Hubspot blog, "How to Write a Case Study: Bookmarkable Guide & Template," November 30, 2023, https://blog.hubspot.com/blog/tabid/6307/bid/33282/the-ultimate-guide-to-creating-compelling-case-studies.aspx

24. Herman Miller Mexico City, Mexico, "How to Create an Office that Evolves as Your Business Does," https://www.hermanmiller.com/research/categories/case-studies/how-to-create-an-office-that-evolves-as-your-business-does/

25. United States Census Bureau, "North American Industry Classification System: Introduction to NAICS," https://www.census.gov/naics/

26. Mirko Humbert, "A History of Business Cards," Designer Daily, https://www.designer-daily.com/a-history-of-business-cards-20266#:~:text=Business%20cards%20began%20in%20the,the%20middle%20of%20the%20century

27. David Currier and Jay Frost, "Be Brief. Be Bright. Be Gone." December 6, 2005, https://www.amazon.com/Brief-Bright-Gone-Pharmaceutical-Representatives/dp/1583480161

ACKNOWLEDGMENTS

Bringing this book to life has been a unique experience for me and a true journey. God planted the seeds of this book in my spirit more than fifteen years ago and I'm excited to see it finally come to fruition. I couldn't have made it to this point without the help of friends, family, mentors, diverse-owned business entrepreneurs, and advisors who encouraged me to pursue my vision and keep moving forward.

Thank you to my mom, Jodene, dad, George, and my brothers, George and Garrett, for listening to me and encouraging me on my journey when I shared this project with them. I also want to thank my aunt, Rev. Dr. Beverly Hair, my uncle, Dr. John Hair, and my cousin, Dr. Melissa Jordan, for believing in me and inspiring me to take a leap of faith to just write this book.

I want to thank supplier diversity consultant, Ralph G. Moore, for training me, and many other supplier diversity leaders in this field. They discussed with me supplier diversity, supply chain strategy, securing executive advocates, and making an impact in this field throughout the various stages of my career.

Thanks to all the supplier diversity advocacy organizations for championing small and diverse-owned firms, providing multiple methods to help corporations connect to them, and championing your corporate members along their respective supplier diversity journeys.

I also want to thank the hundreds of small and diverse-owned business entrepreneurs I've met, consulted, and coached over the years who shared their appreciation for the insights and feedback I shared with them, and encouraged me to keep helping others.

My thanks as well to Brad Wilson for contributing his expertise and insights on how to successfully respond to request for proposals, and Philip Uwechue for contributing his expertise and providing the mathematical calculations shared in this book.

Thank you to Debra Quade, Valencia Cooper, Nedra Dickson, the Council of Supplier Diversity Professionals (during my era as a member), D12, DPC, and my network of supplier diversity colleagues. You are all an inspiration and a wonderful support system that lifts me up and helps to keep me going.

A special thank you to one of my editors, Claire King, for being interested in working on this project with me, being my coach and cheerleader, challenging me, questioning me, and helping me to tell this story. Her partnership gave me the additional confidence I needed to finally carry this book across the finish line.

A special thank you to my publisher and their entire team for their expertise in pulling the final book together and for coaching me along the publishing journey. I appreciate you and thank you for doing an amazing job.

ABOUT THE AUTHOR

KIMBERLY R. COFFMAN is an esteemed leader in supplier diversity and the founder and CEO of Kimberly Rae Consulting, LLC. With a career spanning roles at renowned corporations like Delta Air Lines and Herman Miller, Coffman has championed transformative initiatives, driving global supplier diversity strategies and integrated marketing communications programs. A dynamic speaker and panelist, she actively contributes to serving on committees for diversity-focused organizations, including the Financial Services Roundtable for Supplier Diversity, Disability:IN's Procurement Council, and the National LGBT Chamber of Commerce's Corporate Advisory and Procurement Councils.

Coffman has also chaired industry groups, served on boards, and contributed thought leadership through research reports on supplier diversity best practices. Recognized with prestigious awards such as DiversityPlus magazine's "Top 25 Women in Power Impacting Diversity," Coffman is committed to fostering inclusion and

empowering minority-owned businesses. She has a bachelor of arts from Michigan State University, a master of management from Aquinas College, and a Supplier Diversity Excellence Program certificate from Tuck Executive Education at Dartmouth and currently lives in Atlanta, Georgia.

Learn more at www.KimberlyRaeConsulting.com
Connect on Instagram at @kimberlycoffman

publish your gift

CREATING DISTINCTIVE BOOKS
FOR LEADERS AT THE TOP OF THEIR FIELD

We're a collaborative group of creative masterminds
with a mission to empower leaders to share their unique
knowledge, insights, and experiences with the world.

Our expertise bridges the gap between
their wisdom and ideal readers—delivering impactful
self-help books that inspire lasting growth and change.

Want to know more?

Write to us at info@publishyourgift.com
or call (888) 949-6228

Discover great books, authors, and more at
www.PublishYourGift.com

Connect with us on social media

@publishyourgift